WALTZING MATILDA

WALTZING MATILDA

by Alice Notley

THE KULCHUR FOUNDATION

WALTZING MATILDA
by Alice Notley

Published by the Kulchur Foundation
888 Park Ave., N.Y., N.Y. 10021
Copyright © 1981 by Alice Notley

Library of Congress Cataloging in Publication Data
 I. Title.
PS3564.079W3 811'.54 81-14272
ISBN 0-936538-04-X AACR2
Printed in the U.S.A. by Capital City Press, Inc.
Montpelier, Vermont

FRONT & BACK COVERS
by George Schneeman

Some of these poems have
appeared in ABRACADABRA, MAG CITY,
BROADWAY, & UNITED ARTISTS. "An
Interview With George Schneeman" first
appeared in BRILLIANT CORNERS.

For Me and Ted

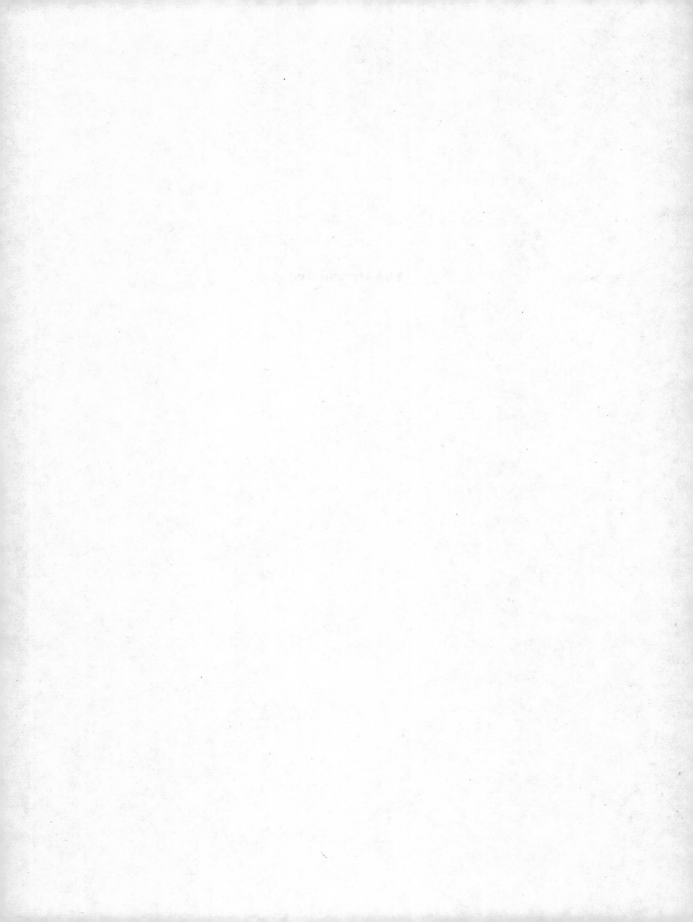

CONTENTS

WINTERS OF FEW POEMS

I want to play
that is, drink and
write, but I'm
a strange child
waiting out my childhood.
I heard poems!
wild refrain: to dress
like a whore, & lipstick'
No where to go
but home (oh I
thought I should never
see you again).

She gets older, & I am she
She gets heavier, & I am she
Her face gets lined, & I am she.

When she's filled with panicks & dreads,
 I am she
When she lies shallowly in a bad dream,
 I am she.

She makes a poem she likes, & I am she
She sings a song of only hers, & I am she.

I am she
I am night black wander
I talk to oceans, I enjoy myself
I never have to go home
I ask for nothing, no mercy, no, nothing.

A DAY AS OLD AS EVER ALL DAY

Between 1425 and 1465 when
everything could be clearly seen,
I was in love with the
figures in the landscape.
Now it's January,
the light is just a clear glacier
holding everything, everyone in place
& relentlessly being my heart,
my lady, my lord.

BIRDS RESULT IN ITS

Birds result in its far not thrive a fossil
where are they? among the more myths as well
are they birds young water birds? out of
pity the gods changed them both into birds
nest floated in the solstice sea. Am, am I there?
black skimmer dips its lower bill in water
a walk across a lily pad. Yes. The white-
faced tree that which stands in their midst.

WHAT REALLY GOT ME

That really got me. Every time I think of that.
Other people that were two days into New York City.
I could have had an unbelievable career
as a miniaturist. Yep. A fortune no doubt. I love it.
Edmund Waller & a few ladies cloistered in towers.
Good morrow sweet drugstore. Would you
show me how to use that brown thing again? So that
everyone can see that I am really
a Scottish laird, and hadn't been made a
complete emotional infant at the age of thirty-five.
But he could beat me up so I didn't want to tell him.
Last night I went home and developed a considerable slur.
Now I sound like me for the first time.

I WATCH THE 1977 ACADEMY AWARDS

I watch the 1977 Academy Awards and cry
at the presentation of every award---
best animated short subject, best
sound effects for a black & white actress,
best supporting emotional acceptance speech,
best bridging of the gap between serious
radical political activist & actor/actress
can't help him/her self in terrific clothes but
thinking he/she is really secretly infiltrating the
Academy. Jane Fonda looks gorgeous, as if tough
with everyone, and disparages the prompt-cards.
Cecily Tyson in white (I read the fashion preview
in the *Post*) 19th Century batiste, is achingly,
strivingly as diction-perfect as Lawrence
Olivier. Jane Fonda quotes someone I study
every day---I'm too emotionally overcome
to remember now, Tolstoy? Philip Whalen?---to
be effectively serious enough to introduce
Norman Mailer, who mostly thinks it's an
amazing gas to be among stars---all writers are
star-fuckers---and who presents one of those
forgettable *prestigious* important awards, best
original screenplay? Paddy Chayevsky. Shit,
he probably gets to go to a lavish post-awards
party and he's only like me, a writer. Faye
Dunaway accepting hers has above her black dollars
dollars dollars dress a sensationally casual
hairdo---she's pretending she's just like me!
but her cheekbones like jade insertions, something
hard & costly, she rips through her speech from
Network, love her! though the movie obviously
stinks. *Rocky,* ugh. Everyone mumbles and not
excitingly like Dean and Brando and other forms of
priceless electricity. Please no more appalling
mere artistry. I'm dying to see *Bound For Glory*,
we all know the plot, then, I cry 'cause Barbra
Streisand gets an award for---we're amazed---best
song, she's so versatile! it's a terrible song, I

18

had a drink in the kitchen while it was being sung.
Who I like is Jack Nicholson, the nevertheless-sexy
intelligence, who thinks he can get by the implications
with his coy vegetable routine. Honey, you can
by me. Honeys, you can get away with anything
by me. All I really want is to cry ecstatically,
or laugh---we know you're all rich, shamelessly
we pay for it!---good tears have never been cheap.
And if you've lost your character you've also gained
mine! I've draped it all over you tonight help-
lessly, like this season's most clinging
miles-off-the-shoulder dress.

DAY BOOK

11/20

Flunking out on everything
Eyeless beer-filled smelly of stocking
Voice in wall car in wall, its
length and gone---

It's cold
I bequeath to you
the works of Franz Schubert
(he certainly won't mind)

as heard on radio tonight until 2
along with child's little snorings
bits of paper
stilly dot the floor

A thing of antiseptic importance
has been banished from the music
to hover cold-wind-like
just out through there, that---

Or that's what the song says
I'm just singing it

11/23

Europe meets America
a week ago tomorrow
circa 7 PM---

"The pencil of my
uncle is in the garden,
near my aunt."

Things that are over-
rated: reincarnation,
dignity, democracy.

Used to work for me
in the brush shop.
He calls me Apples

'cause I once had
an apple with 4 worms.
I know some of

them inmates better
than I know my own
family. It's called

complete feather-brained
genius. You throw a
brush at him

so you can paint
a picture. See,
he figured it out,

but he can't smile
about it, can he? he's
a born being too.

But, to do this well
I'm true and helpless.
I'd die for you, too,

though, you fuck-head,
I do hope
I don't have to.

Streetwalker Song

What will suit you
and it's raining
my socks are soaked
rain suits me

What will suit you
and it's snowing
my magenta mohair
cap is white

What will suit you
when the sun's out
warmth and leaves and
shadows will suit me again,

I think, will warmth
suit me again? Yes.
and old customers will
and new customers will

A king must remember
a business man must
and a partisan must
must remember

who they hate and what
who they love and what
I refuse to remember
Everything suits me

not a hard road. Desert I came from,
cold now. Well hard road's what you
say if there's been some time. No,
hard road's what you say if there's

been some time that's the same time re-
peated over & over by everyone. Everyone
already said it's hard. A *road* is *hard*,
that's how it holds you up, or, well, no

but, been some time that's already said
It's hard. It's easy. Making the poems
for everyone that they don't read but seem
to agree have to do with living civilized-

like being going on. Not that they who? would
think to say it. I've never cared if
they did, either, said it or read them.
My pastures of plenty must always be free,

that's because they're mine. I possess
where I do it. Where is it? Don't know.
What is it? Don't know. Who is it?
Dust friend wind gone river multiple.

1978

DREAM

In the prologue to the dream, I'm
with my mother and my grandmother
in my grandparents' old house
in Phoenix. Grandma is sick
suddenly, and Mother and I
wonder whether or not to worry
and is this the time she'll die. Then
my mother decides to take it
lightly. Grandma has an attack
of diarrhea, right there. Mother
lays her down on the bed and covers her
a little and is going to
get the things to clean her with. "Don't worry,
Mother," she says. Then she giggles,
"You're covered with sweet-smelling waters
down there"---her legs---I realize
"sweet smelling waters" is
some funny euphemism they
both know. They both smile.

In the real dream, there are
large grounds, like a college,
and grass, and a house with several
stories, and rooms full of people.
Ted has a drug which when you take it
makes you disappear in front of
everyone, poof, vanish into air.
Initially, he has disappeared,
and I'm furious and worried. We
aren't married yet, I guess. When I
see him next, he tells me the drug
makes you disappear into a
parallel universe. He likes it.
"Fairfield Porter is alive there,"
he says, "and I talk with him."
"Who else is there?" I ask. "Two or
three others and a lot of girls," he
says. I feel impotently enraged.

He tells me that when you're in the
parallel universe you can
also be invisibly present
in this one. Undetected he
had listened in on a recent
incident between Larry Fagin
and someone. Next, Anne and Larry
and others and I and Ted are
in a room and suddenly Ted
takes a pill and across the room
from me---poof---he disappears.
Anne says, "Oh he's done it again.
Peter told Allen that he didn't
care if Ted did it if he'd only
tell everybody beforehand."
I find on the table some of
the pills, which Ted's apparently
left for Larry to try, and I
steal them and put them in my pocket.
They're pink and there are 2 sizes---
one huge like a methadone bisquit,
one small and round. I remember
Ted had said one and a half (large)
might get me there. I rush outside and
swallow one and then some, I'm not
sure if it's a half. Within
moments I disappear, which is
like rising into the air---it
was light but as I "disappear"
it gets darker, then I'm overhead
flying, and time is different---
it's 16th century or 19th
century but no it's just what-
ever the parallel
universe is---and I alight
at a presumably 19th
century saloon. I enter.
People are formal in a
robot-like way. A man grabs
me and says, "No niggers allowed
in here." I scream, "I'm not a nigger!"
He lets me go. "Can you direct
me to the billiards room?" I say.

He points to a door. I enter,
it's dark. Ted and others are at
a table, maybe they're playing
cards. I approach all happy and
Ted says, "Hello," quite impassively.
"But it's me," I say. "It doesn't
make any difference," he says,
"just because you came here." I start
throwing glasses at him and try
to break the window too. He stays
impassive, though with a slightly
puzzled smile, and the window won't
break. I give up, and all the rage
goes out of me; waiters come and
clean up the mess. Someone tells a lame joke.
I sit down at a short distance
from the table, but a man and
a woman come and talk to me in
a very friendly way. The man
asks me if I know Gunnar Harding
and fills me in on parallel
universe literary gossip.
In this universe, Anselm Hollo
and Josie Clare have remained
happily married, they even
have a new little daughter.
"Have you read Anne Sexton's new book
of memoirs?" the man says. "It's very
good, surprisingly enough;
it's called *Memories*." The girl, a
pale-skinned dark-haired girl, shows me
various books. I look at the
cover of one and say, astonished,
"Does Jane Freilicher live in this
universe?" "Why yes," she says. "And
who are you?" I ask her. "Why, I
am almost exactly Simone Weil."

FIRST PRE-SPRING IN FIVE YEARS
WITHOUT OWN CROCUSES

Why today is the first of the lovely springish days
yet I've used up all the praise words other years
and see & hear & smell nothing specific to
tell am only the one sense which is a body
body knows it's one of those good warm days
so body walks with my son down the sunny Avenue
at 6th St. a stooped-over old man teases him
obscurely, pointing to his little boots
"those are my shoes, take them off and
 give them to me"
stooped-over old man's own shoes are fine,
 shiny, old-man, & black, and
my son declines to give his away we smilingly
walk away and then I notice, & shocked,
why, my son's shoes are on the wrong feet! and
stooped on the sidewalk righting them I
wonder again why lately all the messages
 have to be obscure
I suspect stooped-over old man of being a
 supernatural agent
and make a secret promise to him which I don't know yet

Clouds, big ones oh it's
blowing up wild outside.
Be something for me
this time. Change me,
wind. Change me, rain.

I'm tired tonight, aren't you?
I need something soothing to
read. I'll take this & I'll just
open it up to something nice.
The moon's too bright for stars.
I feel funny---but I believe that
I'm so tired and here---
and you, your're not so tired---that
I get depressed but I'm extensive now
I'm very big & it's big here
even where this funny house is.

TOMPKINS SQUARE PARK

Some of me falls down on me
in pieces and rustles some of me
they use for lewd purposes why
shouldn't they there's a leaf
on Charity's nose and Hope's is
probably bobbed or outright corroded
but it's hard to keep track of all
these these . . . when the wind is
blowing my surface away
everything tiny, moving, and delighted
gone---I'm black and
grey and white and sky-mingled again
A man is sweeping me softly. A drunk
lies down. On me who am
turning, circling the bright screened one.

FLOWERS OF THE FOOTHILLS &
MOUNTAIN VALLEYS

Compassion is pungent
& sharply aromatic. Small
yellow heads in late summer.
Love & hatred are
delicate & fragrant.
Around a yellow disc.
Glory is found along the shores
intoning "I change but in death."
Sincerity has delicate &
feathery leaves. Dignity is
fragrant & looks like a little
brown nail. The leaves
of hidden worth are deeply cut;
a 19th century American
artist & inventor. Sir
Thomas Campion blooms in July
pinkly with notched petals. The
clearest of gins taste of
bluish protection, lovely
Mary & little Jesus found
refuge, in Egypt, in gin.
Hid from sight in
the bark of the cinnamon tree
a light flashes on & off,
dazzles, whistles. Remembrance
is the most fragrant, love is
the most dark pink, courage
is grey-green growing wild.

Oh I did wrong and
bought doughnuts
instead of the rolls.
Last night I asked Dad
if I could buy
doughnuts in the
morning, instead of those
rolls, if they didn't have
the cherry kind---and he
said, Anselm everyone
likes the rolls best. Oh
I gave in and bought
the wonderful box of
mixed doughnuts. And I'm
walking in the door
and I'm telling Mom
they didn't have the
cherry ones but the other
2 kinds & so on--- and he's
overheard me and yelling at
me. I'm crying, crying like
anything and feeling so bad.

POEM

I'm very, today, melancholic tense
Want ageless delicate dinosaur sweetness
Or that of clusters of tiny blue spheres, as flowers
Existing everywhere here now in clear intelligible manner
Do you think I will see my Daddy when I die? I asked
Days ago, of my husband, sleepily wistful
Maybe he might glance at you over his shoulder
From a long way off, he answered who's gone east
To see his mother this heavenly morning
She has lung cancer, wants, says she, to make it through
One more World Series with the Red Sox. Doubtful. Lively Peg
He married me, we say, because I smile like her.

POEM

I believe the yellow flowers think with me
& that Charles Olson's arms are all around
"You can't say that can you Alice?" Bernadette
Her voice in on it too, all the way from
New Hampshire, farther than cloud and cloud
It's going to rain on us when that branch there
Stops rustling. Have a last sip of my Calistoga, Sweets.
The first drop, the shade darker. "When
It starts to rain Mom I'm still gonna go to Merrit's
With my big coat on and play in the rain."
The tree just changed colors! it's glowing
A light chartreusely---it's all for Charles though
The earth slopes kindly down around me as if
To say the closure will be a little, just a little, like this.

NIGHTS IN THE GARDENS OF SPAIN

for David

CHAPTER I

"It was an insult to my aesthetics
just to get these fucking letters."

CHAPTER II

"Fuck them dishes I'm this hardworking teacher."

CHAPTER III

"This is complete bullshit
I don't dig it."

CHAPTER IV

"What a lot of bullshit."

CHAPTER V

"If there's another Hitler I'm
telling him all about you."

CHAPTER VI

"You dumb-bell."

CHAPTER VII

"If you take 2 of these you have the feeling
your wife has departed on a round-the-world tour
for 2 years."

CHAPTER VIII

"I'll be damned."

CHAPTER IX

"Play the cards will you
you're breaking my heart."

CHAPTER X

"Why doesn't she go to
Israel and fight with the terrorists?"

CHAPTER XI

"What a lot of bullshit."

CHAPTER XII

"What bullshit."

CHAPTER XIII

"You know I can't waste my pills
I'm working on Paradise Lost."

CHAPTER XIV

"This is a bunch of horseshit if I ever saw any."

CHAPTER XV

"That's the way I like to see it."

CHAPTER XVI

"You'll say, 'Many years later I
found he was a ne'er-do-well poet
living with a slutty vixen in
Boulder, Colorado.' "

CHAPTER XVII

"You'll say, 'Mother was very popular
she always caught the clap in Mexico.' "

CHAPTER XVIII

"What a bunch of bullshit."

CHAPTER XIX

"You didn't help my crib any I must say."

CHATER XX

"What a bunch of bullshit."

CHAPTER XXI

"27 versions of Ravel's Bolero."

POEM

A clitoris is a kind of brain
That woman stroking hers in *Hustler*
is thinking: I wonder, are there
misprints in the Manhattan Telephone Directory?

Apartment too small
too crowded too old and
beautiful, keep us
gracefully for one more
year. Many stars on
your face, fading away.

VERY LATE

What these dead people do.
Near the flower stalls something. They
give you the that you sing or hard
push towards crying. There was this
guy. At moon just past first. "Hey
guys why doncha go to sleep?" Good-
bye old sweethearts & pals. Hello
auto supplies hello no-name car-boat.
Blown away thistledown the important
things I learned, I don't even say
things like this, my phony, but
but and you now YOU---& you had these
politics & they were supposed to like
woman to woman be of benefit
be of benefit, free me & all when all you had to
do to free me & all was learn to be
amusing---believe me we'll be two dead ones
sipping dry ones next the sky pool---
Well of course I freed myself. I amused
myself, every single time. I
read the books & built the tables & studied
THE EMPIRE STRIKES BACK & tried to
amuse YOU while you were trying to
rhetoric me you who were gradually found possessed
of the curiosity of an airshaft window.
Ah, what kind of mind mine? I was
only stumbling past. There was this guy.
Friends & people free each other by being interesting---
because anyway they have to pick flowers together
on the Milky Way forever. There was
this guy. I'll say Hey once I knew this woman
who didn't even want you to say certain
words. She's dead. Hey I knew this midget
same thing. He's dead. What have they
to offer death? Do I hafta leave my songs
behind? But boy will I amuse Death! I'm gonna
amuse & free death with skill of these
jokes & pornography & serious posturing

& the possibility of every & each & the *care*.
This Death don't care about rhetoric,
Death says amuse me just amuse
me & you'll be free & free me from myself, more
books more Scotch more bedbugs more
funny stuff, more. Death says, When you were young I
loved you as my life---I still do---

Let it happen again---
and what can I promise?
Lake of the Woods, Great
Salt---let me rest in my
poems again Dubawnt
and Eyre, I've rejected
"the pearl of," but not
the perfection of, Onega
Ladoga, Tanganyika
which is dedicated wholly
to you. Issyk Kul
gods of my rest, Great
Bear, Maracaibo, but
I know no words but
your names, Kyoga
Mweru, an old
World Almanac 1963
Torrens, Reindeer
contains your sudden
names the gods are
everywhere unexpected-
ly, but will you
help me? Albert, Urmia
I'm calling on you
that I may be perfect
perfect to serve you
for no reason except for
Perfection and for you
Great Slave, Caspian Sea
you are the gods, you are
the gods, I know your
secret names for today
November 7th 1980 Across
the desert across the
water across the various
Chinas across the street

ARIETTA

Can this room
be a song?
The shutters and
curtains. The
windows November
gets through,
she's a black wind
already and the faded
curtains stir. Shall I
buy putty or call
Russel? Shall I
mist the birthday flowers---
do they prefer to be
cold & dry or
cold & damp? Shall I
insert a political
comment?
Shall I become a
hotel management?
a coloratura item?
I shall be sad,
sadder than you
because I'm clutching my
jacket closer. I shall be the
author of a few notes sung
to beg splendid lingering
of the light broken
at the crossroads sexual
dirty freezing thighs
of the pale grape room
that contains civiliza-
tion as I know it to be an
aging beloved that I
love and for no good reason.

LIKE FRANK

Pain at rest to sweep & everything
Meditate landscape of human eternity

 (Pause)

"My slightnesses haven't gotten any better
It's very sad
I bought something to clean the paintings with too"

"A strong resemblance to Chester Allen Arthur
should be a slight resemblance to Abraham Lincoln?"

"Yes. I mean
No."

 (Pause)

"the Guggenheim for Chrissakes"
"frankly I mostly have to wash my hair"

I miss dinosaurs
I miss the Elizabethans
I miss Deedee, & Grace, & the pretty one
I miss *Cooking pot 77¢*
I miss the trees on Waveland
I miss Edmund's infant body
I miss Ted's old coat
I miss shooting up
I miss putting off being older
I miss my father's handwriting
I miss Steve in the orange chair
I miss the thought of driving to the Gulf States
I miss Australia and the Tundra
I miss my dark green sweater
I miss living near Kassandra
I miss 13th Century springtime
I miss *Blue Poles*
I miss the scent of geraniums & creosote
I miss music

ONLY POEM

I just hate dinner
& everything. I
hate it. And so
I hate everything.

NO WOMAN IS AN ISLANDESS

for Kate

Dear Meggie,

I miss you a lot you know. So I want this to be a good letter. I hope I can think of
what you need to know from me this minute. Well we had one dance at the Center
and everyone danced for hours except the ones who never do like Jackie and Luna
and you'll be happy to hear, Doug. I think he does like you after all even though you
were so silly when we were blasted that time at Juno's and you kept saying "oh go
snorkel a Snicker's Bar." He probably didn't hear you anyway because he was stand-
ing next to the speaker then as I remember it. He's cute but I like Bill and I miss him
a lot. He's away at his grandmother's commune for Xmas vacation. He wrote a letter
to Michael Maine and I read it, it said she made him clean the rabbits, ugh. Also
they did yoga in a meadow one day and a bee stung his back. There was a lot of
mud out there and his grandmother put some on the bee sting. Of course I wish *I*
could have even though I hate mud. Guess what? his mother is here fasting with that
boyfriend who you said has a face like an orange rind. I told Tasha you said that and
she said she has large pores too so you shouldn't make fun of the quote less for-
tunate. My mother went into the city last Monday so guess what I did. I put on her
lowcut velvet party dress and her black coral necklace and a whole lot of makeup.
Then someone knocked at the door and it was Lee Raiment who needed to borrow
some honey. He didn't say anything about how I looked, but it made me spill honey
on the sleeve. You know me, I tried to lick it off before I finally sat for a half hour
cleaning it right with soap. Then I thought about Lee Raiment staring at me in my
mother's party dress and gold eyelash stuff at 10AM in the morning and I almost
cried. If you had been here it wouldn't have bothered me at all. We could have gone
behind his house and stared through the window at him and Sara doing you-know-
what. I guess, like you said, you're not as interested in gross things as I am so I won't
tell you about the time with the salt shaker that Tasha said she saw. Well basically he
salted her a lot, but I think you're right Tasha fibs sometimes. Well what do you
think about sex these days? My mother asked me if I'd ever done anything with a
boy. I said I really didn't like the way penises look and now she's worried but I don't
know whether *I* am. Oh I always tell you everything. She wants me to look at this
book of "beautiful photographs" all the time, ugh. I think she'd offer to drive me
down the coast to a nude beach if it weren't December. I just laughed out loud
because I remembered that time Lee Raiment started sweeping their bedroom naked

and you said he could at least put on an apron. That was the time we thought they saw us and then we went to the party where Tasha was high and she got Danny's cat Krishna to sit still on her lap while she cut off half of its fur. You said that acid or no acid that was mean, and you were right. Anyway I know what you think about sex, what you told me on the bus home from school. But I can't remember what you said because you quoted something someone said or something and then asked me if I thought you had to put it in your mouth even if you knew him really well. I think you were confused that day because you were having one of your headaches. Confused or not I wish you'd come back today instead of in two weeks. Tasha's no fun for a friend when you're not here too, all she does is talk about how big her nipples got last summer. She hasn't read a book since then either or thought about her future, except that she said she'd like to go to San Francisco and work in a shop that sells fans and shoes in Chinatown, but you can't if you're not Chinese I said and anyway you have to go to college. This must be the longest letter I've ever written. Tasha's getting on my nerves but it's not her fault, my mother says Tasha's mother's an unstable Pisces with the brains of a piss-ant. I hate it when my mother says piss-ant. So will you please come home today?

Your friend,

Clel

MY BODYGUARD

for Harris Schiff

Turn that off.
I'm sorry I said you ruined my life.
Turn that---thank you.
I wonder what the Meathead just said.
Yeah we wonder that.
Get your ass shutting up.
You get your ass!
I'll spank you!
Spank the goldfish!
Yeah, spank the goldfish!
Is this all the stuff I'm selling?
Why don't you sell him this?
He doesn't like naked pictures of women.
He likes naked pictures of you.
He only likes women in dresses from the nineteen-forties.
Right. Dresses he'd like to wear. He hates pictures anyway. He recoils in horror
from them. Do you have any dresses from the nineteen-forties you could sell him?
I only have my English air-force wife's dress.
Oh well you'd better not sell him any dresses just the books and letters.
You guys are joking, right?
Maybe I should wear my English air-force wife's dress and he'd give me more
money.
Oh no he'll like your new haircut and your leather jacket and all.
You think so?
You look like the pageboy to Sir Bad Knight.
Fuck. I want to look like the pageboy to the other one.

*

How can I be reading Santayana?
He's the worst dinner guest of all time.
Santayana?
No.
Santayana said he liked paranoids and people with smallpox better than regular
people.

50

Anyhow, he doesn't know how to be a ninny and he doesn't know how to make everyone stop being a nest of ninnies. So there he is, stuck in the middle of being a stick-in-the-mud.

That's a form of ninny.

I suppose so. Anyway, he doesn't have the grace to be a good ninny. I mean he takes no real delight in his ninnihood.

Santayana is one of the worst guys I ever read. There's something great in how awful he really is. He talks like God.

Wallace Stevens likes him.

Wallace Stevens is Wallace Stevens. He once made Hemingway promise not to tell anyone he'd knocked Stevens down.

*

Foul. One ball two strikes.

Shit.

What are you swearing about?

Life.

Pretty dangerous kind of play in this situation. Pete Rose can't get in the back door, he'll try anything.

How do you feel?

I fell okay.

Then Concepcion stopped at third and Frank Wein is the batter.

Jesus what a game.

It popped out of his glove and Pete Rose made the play.

Pete Rose! Hah!

Wow, watch Pete Rose hustle.

Look at the canine corps at the backdrop. Part of the security force.

It seems to be something happening.

Guy struck out.

Are all the guys running around and grabbing each other?

Yeah. A man in a suit and tie is weeping.

It seems that this team has been reaching back for something extra since Moby Dick was a guppy.

Are you willing to admit now that what he did he had to do?

For Chrissakes it's only baseball.

*

I feel dehydrated.

Well you probably are.

I feel awful as well.

It says here that this guy said that Herodotus was a horrible liar, but this guy said he

51

himself saw the man-eating beast, the great tiger with a face like a man, two rows of teeth in each jaw and shot darts out of the end of its tail.

Who was this guy?

He was the court physician to the King of Persia. The point is you're not supposed to believe him. Of course it's possible he actually saw it, but since then evolution has made it so it doesn't shoot darts out of its tail anymore. Now we only have elephants that like to listen to Jack Kerouac.

I don't believe in evolution.

I don't either as a matter of fact. However I believe that snakes evolve into peas. Because they're green and round.

Bernadette said our brains control our assholes and not our assholes our brains unfortunately.

She did? She's got it completely backwards then.

She wants you to call someone up.

Everyone wants me to call someone up. Ursula LeGuin wants me to call up Philip K. Dick.

She does?

Ursula LeGuin said Philip K. Dick is better than Borges.

I sympathize with points of view like that.

I do too. She says in Philip K. Dick taxicabs often give people advice. Bad advice.

You sound like Anne Porter's godmother. The one who said Hell may exist but we don't have to go there. That one.

But you do have to go there. Possibly you don't. You could join an exercise club.

I don't think that works. Everyone I know who does that goes to hell.

So does everyone we know who doesn't do that.

I suppose so. I'm sick of reading all these books. Here's the Greek word that means desire to cross over to the other side. *Pothos.*

You mean the Greeks stood on the riverbank and said Pothos! Pothos!

Something like that.

*

Oh look they've put the church drinking hall right behind our house.

It doesn't make any difference since we have to see all those dead people outside.

There's one on a lamppost. It's curled up on top of it. It's a large old child.

I don't think I like this.

Let's go in the house.

*

Say something witty so I can write it down.

Did you hear the one about the couple who didn't know the difference between vaseline and putty? All their windows fell out.

Give her this book to read.
What's a rubyfruit?
Are you kidding?
Is it any good?
Yesterday, let's see I wrote down what he said about it yesterday. Quote. It's sort of irrepressible and things like that but it's not much fun. There's a great plot but nothing happens.
That sounds like *You Didn't Even Try.*
It's about this girl who goes everywhere being guiltless and happy and she always hooks up with two or three girls like herself.
It must be the new Debbie Reynolds story.
How's Herodotus?
Fine. He ain't even dead yet. They don't know how he made his living, they don't know how he got the money to go to these places he went to. In fact they don't know shit about him. They say he asked everyone questions and miraculously everyone answered him and told him the truth. They say it was a miracle because he was no linguist. They don't say how they know he was no linguist.
Maybe when I'm dead they'll decide I was a linguist.
I'm a linguist.
How about this book?
Which book?
Malagueña Salerosa.
Ah, *Malafrena.*
It's great. It's a great book. It makes you burst into tears and realize your mortality.

*

I'm dancing with the Nuyorican actor. His friends came in and nothing much happens.
Where's mother?
She's in the room where the Christmas tree is.
Nothing feels right.
Let's go in here. Thousands of people and cars are here at the stadium for the ballgame.
Let's go in this room.
It's the part where the guy from *Charley's Angels* is putting makeup on me. He's naked and has a huge prick for no reason.
That color of makeup's too dark. You need this rosier one.
Look at these naked women, green and red and all colors.
What's through that door?
Ugh, leeches! They fall on you as soon as you wade in the stream.
I can't get them all off. Well they're mostly off now but I'm not sure.
Here come the Indians to get us. See, back the film up. Here they come again.

Nothing happens when they come to get us.
Actually it's beautiful out here. There's a lot of sky and green leaves.
In the sunlight there's little white refraction sunbursts.

<p style="text-align:center">*</p>

Hi.
Why are you still sleeping?
Ha ha.
Is he there?
Yes I would.
Tell him he only loves you when the weather's nice.
Hi, give me some lomotil.
I thought you might have some.
I don't have any side-effects.
No, I have the stomach cramps and the going-to-the-bathrooms.
When will you be up?
Why is your voice so clear? You must be on the other phone.
When can I come over?
I'll bring her over for lunch.
I'm not going out in this weather!
She says she's not going out in this weather.
They went to see *The Wizard Of Oz*.
With their friend Michael and Waylon Jennings.
I'll see you in about an hour.
Goodby.
I knew that guy would be good for some lomotil. He has a little of everything.
Why?
He practices preventive medicine.
What?
He keeps the drugs around so he won't get the diseases.
You mean he uses them like charms?
Yeah something like that.

<p style="text-align:center">*</p>

Is she still trying to get him to have queer experiences and stuff?
No he did that with a girl and she hit the ceiling.
Oh yeah, that did it huh? You want a cheeseburger?
No I'm not eating.
Are you high?
No.
Why aren't you eating?

I have a plan. Do you want another beer?
Yeah.
Here.
It's nice to have a plan. I keep feeling like I'm always in the continuation of part one.
What do you mean?
Something, I guess. What's the point of getting wrinkles if you can't live with them?
If it's just the continuation of part one you can probably live with them.
Good thinking. Well I don't have a very deep mind right now but I'm also not telling
the right truth.
About what?
Oh well.
I feel good today. I wrote two page-and-a-half poems and a page of prose last night.
For the prose issue?
Yeah.
I think I'll forget about the prose issue. I think I'll write a lot of poems which present
me as a beautiful wonderful all-encompassment of a person. And outgoing.
Outgoing too?
Then either I'll change or I'll be happy being my old selfish self.
You always announce to the whole world how you're gonna change.
Sure. Why not?
You could always sneak up and take everyone by storm.
As you know I believe in telling everyone everything. Whenever I can think of what it
is.
I know the impulse. A person has to open their own big mouth.
Well I just want to keep everyone clued in. You in others this is your soul etcetera.
Everyone's supposed to be shaping me up or me them or both.
I bet you're just trying to justify gossip again.
On the highest level of gossip and poetry it's we're all in this together. You can't go
to heaven without everyone else. Unfortunately.
Oh God if that's true think of everyone you have to be in heaven with.
I know. Isn't it awful?

*

My very words to Bernice.
Who's Bernice?
If I wanted to insult you I'd make a question about your hair.
What if we had a real chicken here?
What if we did?
It would be a, you know---
Rooster?
No,
Hen?

No,
Egg?
No,
What?
You know, Puff the magic dragon.
Puff the magic chicken.
You gonna help me out with the legal fees?
Remember we were sued once by the Sioux Nation for defaming the Indians?
Another yard out for the Bears.
Touchdown Chicago.
Brian Bashnagel holdins.
What's the matter boys?
He doesn't want to play with me.
You can't do that, you can't change your mind.
So tell me some other things she said.
That was all she said. Get me an envelope on my desk and a piece of paper.
That's my desk.
Oh.
Yeah you dumb jerk.
Where'd you get this thing?
I didn't get it from anyone, it's mine. I got it from my grandpa.
You mean my grandpa.
Yeah.
What are the names of your grandpa?
Shut up.
Spareribs and Dingbat? Spareribs and Nobody? Heathcliff and Dingbat?
Shut up.
My very words to Bernice.
That's Fish.
No that's my very words to Bernice. Nobody understands cool except for me and
James Dean. Well life goes on. Well I guess you'll live.
Surprise! Guess who!
Shut up you guys. I don't wanna hear any more. I'm getting a headache.
My very words to Bernice.

*

Lytton Strachey just said he's stoned out on hash.
How does he like hash?
He doesn't like anything too much but they uh write very well.
Does he say anything interesting ever?
He said he saw Henry James twice.
Some guy who owned some Jim's Ice Cream Shop in uh San Diego or San Francisco

or somewhere, some friend of Judy's, he got hepatitis germs in the chocolate ice cream and some three hundred and fifty people had to get hepatitis shots and he had to pay ten thousand dollars for them.

Did he go bankrupt?

He already was. He couldn't pay for them. Lytton Strachey just said, "Maybe you'll be able to tell me how absurd I am at tea on Tuesday," and Virginia Woolf says, "I'll be glad to. If there's anything a Yorkshire woman can cook it's a muffin."

I'm running out of ink. I don't have any normal people's pens any more.

I'm going to go out. I don't know why. I'll just get cold and I can't think of anyone to ask for money. Give me that twenty-five cents.

They have those tiny pepsis at the corner store.

They're thirty cents now.

Ask a wino for a nickel.

I'm just making sure I don't have to go to the bathroom.

Put it in positive subsidy.

My wife never got 500,000 dollars from the Iranian government.

I just want to do the same old thing differently. But I feel too slow and a little blind, like Ellen Terry in her blue glasses.

I'll take the garbage down.

It's all smeared.

I'm Rainey Hughes of the Dallas Cowboys.

This year I had some problems with the wind.

We had a lady she was demon-possessed. The girl came in. I didn't know her.

Fifteen years?

Fifteen years.

Come in.

Sugar?

I read in the movie magazine you want very much to have a baby.

Humanity has been spared a third world war.

There'll only be two of you here. The one that ain't you is her.

He'll be here any minute.

One sad note: Buffy Nielson busted his left arm.

Mike Fuller has been known to play some tricks as a holder.

Is that you?

I got a free newspaper and a free pack of cigarettes. And I charged some fig bars and a pepsi.

What's it like outside.

Cold. What's it like inside?

I guess it's warm.

*

I've been having flashes again. I need you to tell me I'm a good person.

Well you are a good person and we don't need flashes too right now.

That's certainly true. Well I'm not as good a person as Ellen Terry. Anyway, I figure we sell these books at Danny's if nothing else comes up. Do you have any paperbacks by your bed?

No.

We have two of *A Change Of Hearts*. Should we sell one or give it to someone we know?

Give it to someone we know.

There's a moth flying in circles about an inch above the floor. Will you get the buzzer? I have nudes and paper-doll clothes all over my lap.

Hi.

Hi, what do you have for me?

Here's four home runs and eight base hits.

How about a few more home runs?

What are you doing in there?

I'm perfecting my new speech defect. How do you like them?

Hmmm. Jumbo Soft Shell Crabs is great. I like Filet Of Sole a lot too.

What about Hot Coffee With Cream?

She's too light, she should look South American.

She's dark on top.

"She's dark on top." It's too hot in here.

Yawn.

Have you seen Frankenstein lately?

Not for a few days. A whole week maybe.

How about the soap opera family?

I saw them yesterday. They're okay.

Good. Got any valium?

Oh fuck. Well I can't spare too many. I'm trying to develop a new mental apparatus to deal with the fist of dark depression.

You've been on them for years.

So obviously I have to develop it on them.

I always tell it I'm on vacation.

The way you look you probably are. The gone-fishing kind where you catch a six-pack instead of a fish.

Six milligrams I catch, I hope . . . Thank you.

I wrote myself a note, get the happiness part into your work again.

Are you guys really still supposed to be it? How can I face a lifetime of you?

Hi.

Oh hi.

I almost called you up to borrow a dollar last night.

No we don't have anything.

Why don't you offer him a poem for the money you owe him? A nice lesbian love poem mysteriously dedicated to him.

Ha ha.
I'm really sorry we don't have anything today.
Bye.
What are you doing with a German dictionary?
Revising Hit Hitler's speeches.
You think that's funny?
No I'm just laughing because she fluffed a word.
I fluffed it on purpose to make you laugh. Because I'm a good person.
She's pondering her character today.
You once said something like I was an an awful person and had a perfect poet's character.
So what do you want for your money?
What money?
That's what he means.
You jackass.
I want even worse character so my poems will be even better. Is that the right answer?
No.
I want more money?
No.
Yes.
Actually I want to go to the bathroom.
There's nothing the matter with your character except your sullenness . . .
Your vicious tongue . . .
Your conceit and pride . . .
And your weak bladder.
Perfect poet's character except the bladder maybe no that's good too.

*

Here's the room. We're here.
We're late for the wedding.
How can that be?
There's nobody here now but the bride.
It's my cousin Jeannie.
She's working doing something in her wedding dress.
She's bent over doing something at the table. Mixing something in the bowl.
It's a big room.
Has the wedding taken place yet?
There are people to chat with.
Everyone's talking to each other.
Jeannie's smiling and talking too.
I have to tell you something and then turn aside and talk to you.

There are blue shadows between people, there's a comfortable forest of legs. Jeannie's having a good time.

<p style="text-align:center">*</p>

Don't freak out, Godfrey, or Isabell, or whatever your name is. Doll.
When do I get to wash my jeans?
Whenever. The same day I get to wash my pants.
The crotch of mine smells worse than the crotch of yours.
I don't doubt it.
Today I heard Vicki Dr. Sugar's nurse call up somebody and ask them if they could sell a restaurant for her. The Hickory Pit on something street.
Oh yeah?
Pretty interesting huh. And the bus ride home was interminable but all the side streets looked red. There were lots of stop lights and red neon. But on the way to the doctor's I was walking down the street and nearly collided with two guys on skateboards and one guy was saying something like, I don't think *Arrowsmith* works all that well in that respect either.
It's nice that people still talk about that book.
And I didn't get to see the Princess Cassamassima Ice Truck today. Or the Pearlgreen Hardward Truck. Oh well. I saw the Earth Angel Restaurant sign though and some yellow trees. And a taxi driver made a speech to me about why *Don Giovanni* sounded funny in German.
Anything else?
I told Bob Wilson how I was made desperately unhappy by the pimple on my chin.
Let me see it. It looks like a tiny extra chin.
Fuck you. And I finished the Nigel Nicholson book on the bus.
How did you like it?
I liked the parts that seemed made up because they sounded so familiar.
Can I quote you on that?
No, I already don't understand what I meant.
It was quotable.
How about "I'm having a deja-vu because the clock says it's one-thirty?"
How about "These Foolish Things Remind Me Of Bernice"?
Ugh.
I think I'm feeling affectionate.
Ugh.
Will you take me back?
From where?
Huh?
Have you been away?
I don't know.

Sure.
Sure what?
I'll take you back.
Okay.

Oct. 20–Nov. 4, 1980

SPRINGTIME IN THE ROCKIES

Dark Mountain:

> Like it as big as the moon.
> Necessity of rough cast. Grouch.
> Tender-hearted slob grump, I'm almost
> ready for my act the sun's rising.

Light Mountain:

> I feel as breathtaking as um Yawn usual.
> Let's see. All my snow's in place.
> Hi, Dark Mountain! It didn't snow
> on you again, you bleak old thing.

Dark Mountain:

> I didn't get to sleep all night.
> My shoulders & neck feel like they're full of
> rocks. New rocks. Bad rocks.
> Do I look violent & irresistible?

Man:

> My wife just said chas farish. Hey
> why'd you make that funny noise?

Woman:

> I didn't make any funny noise.
> I don't make funny noises. Dammit
> I was asleep & you woke me up.

Man:

> Liz said she has a brother that has
> a bigger nose than she has. Allen
> has never been up to Michael's before.
> Have you seen my nail-clippers?

Woman:

> Let me go to sleep, it's dawn already.

Light Mountain:

> I feel wanton as a river or a living
> creature. Maybe I should seduce
> Dark Mountain again. Dark Mountain,
> when I woke up at midnight
> last night, I realized I'd dreamt
> of your tarns again. They made me
> feel so melancholy & yet so tempted---
> you've got the sexiest tarns of
> any mountain around.

Blue Thing:

> The next part is, Light Mountain offers
> Dark Mountain a few quaaludes
> & a pernod, Dark Mountain gets
> expansive then sloppy then slurps
> all over Light Mountain's shoulders.

Light Mountain:

> Shut up, Blue Thing! You're just jealous
> 'cause you're only a figment.

Man:

> She just said figment. Hey

you're talking in your sleep again!

Woman:

Oooh! I was dreaming . . .
You gave me a new kind of pill
then while we sat chatting on the couch
three red flowers grew on my knee & then
more of them grew all over my lap
& I knew I could never, never
get up. You said the pill was
called an Interlude & was an
all-day pill, at least. Then there was
Colorado Pittsburgh Oklahoma and
New Mexico, lots of telephone poles were down,
'cause I was hitchhiking in a very
little car, I mean being driven
with a lap 'cause that pill was like
riding. And there was snowing . . .

Man:

What about figment?

Woman:

The pigment was blue.
But I have to sleep now.

Man:

She's asleep again.
Well it's a beautiful morning.
I might as well give up on sleep
& go out for a walk. I wonder
how the Rockies look today?

THE BOUQUET OF DARK RED MUMS

1st Flower: But I am a current event, aren't you?

2nd Flower: I wish someone would bring me a wet thing.

3rd Flower: Pills please.

4th Flower: And then he said, "I don't remember you from Noah's Ark!"

5th Flower: "Pool table."

6th Flower: I smell good.

7th Flower: What's Ed's number?

8th Flower: My French one, oh!

9th Flower: Myself, I desire a prose that could narrow to verse.

ACT II: THE PANDEMONIUM

1st Flower: Walt! Bob! Emily!

2nd Flower: Oh, when I used to do this I was brilliant!

3rd Flower: How do we climb in our shoes?

4th Flower: Use a drum or a trumpet or a whistle! Use anything!

5th Flower: I cried in the first grade when I made my first mistake!

6th Flower: 35 petals have fallen from me And I still have 35 more!

7th Flower: My hair's a mess!

8th Flower: Pray walk softly, do not heat my blood!

9th Flower: I hate everything, even my cocaine.

ELEPHANT & OCEAN

ELEPHANT: I'll never never be your beast of burden.

OCEAN: I'm not too proud to beg.

ELEPHANT: Well while you're at it would you unbottle a soda for me?

OCEAN: Who do you think I am, Mistress Hostess?

ELEPHANT: I suspect you of being a medieval olfactory missile of very large proportions---Ooops! I'm looking at my reflection in you.

OCEAN: How the hell did I ever get mixed up in this conversation in the first place?

ELEPHANT: You said you loved me. You said you loved how solid & smart I am. You said you wanted to get all over me & wriggle down my back & legs & be inhaled & exhaled by only me. You said I made you wet & trembly. You said all those things.

OCEAN: So I did. Then I asked you to take me away to dry land & you said you wouldn't. You just shook your trunk almost imperceptibly & sniffed & said no. Oh I hate you!

ELEPHANT: You're a nice color when you're angry---Prussian blue & blackish dark with orange glimmers from the sun.

OCEAN: Please take me with you!

ELEPHANT: You'd ruin all the mud in the jungle. I'd never wallow again. You'd turn it all to foam---foam birthing silly little Venuses no doubt. I need my mud. It cools me off & soothes my mind without making me have to swim for my life. It doesn't constantly tap me on the shoulder & start fingering me like you do. Sometimes you give me the fuckin' fidgets! I want to hear my feet go splat & my legs go squish while I whistle my favorite song.

OCEAN: Darling! You never told me you had a favorite song!

ELEPHANT: You never asked. You were too busy striking poses: "Now I am tempestuous! Now I am profound! Now I am serene! Now my hair is windblown!"

What the fuck! You never even read a book. Nothing to talk about but yourself! You never even talk to other oceans. If I were an ocean I wouldn't use Gibraltar as an excuse to turn away my petticoat & not even say hello to the Mediterranean. That girl's been around forever & knows plenty.

OCEAN: But Darling! what's your favorite song?

ELEPHANT: Stop trying to change the subject. Oh, what's the difference! My favorite song is "Danny Boy." And now, it's back to the jungle for me.

OCEAN: You're the only elephant I've ever seen or ever will see. Why did the gods make you to be the one elephant ever who made a wrong turn . . .

ELEPHANT: I was pondering my past lives too hard.

OCEAN: And why did the gods make me to be the one ocean capable of falling for an elephant instead of a sky or a sun? It's all so unfair.

ELEPHANT: Well listen I'm going now. Goodbye. You really do look lovely. But goodbye.

OCEAN: He's turned & gone. What shall I do? Shall I rage & destroy a coastal city? Shall I become pure sorrow & then evaporate? Shall I swim north & freeze to melt only when he loves me? Shall I shriek with the gulls & clutch at Hart Crane's bones? No, no. No, I'll just wait right here till the sweet idiot gets lost again. Yes that's what I'll do. Because that's what he'll do.

finis

THE WALL OF PAINTINGS

LADY IN THE CLOCK: Oh Mama, give it all up.

LADY WITH BREASTS: You're not giving me a break.

WIZARD: There's a girl 2 inches tall on my knee.

BLACK OVAL: Astor Plaza, my favorite movie theatre. 2:35, 5:25, 7:25, and later. I like it best. They have the best candy and stuff too.

LADY WITH BREASTS: I can't go to Rhode Island and have everyone have seen THE EMPIRE STRIKES BACK but me . . . That's not what I meant to be thinking about.

LADY IN THE CLOCK: What're you doing?

LADY WITH THE BREASTS: I'm fiddling around with my notebook and getting things in my eyes.

LADY IN THE CLOCK: What kinds of things?

LADY WITH BREASTS: A red butterfly, a skeleton all dark inside it, an old moon in a blue tree, a lot of old blue glitter and stuff. No I'm kidding, I meant dust.

WIZARD: Now I'll tell the 2-inch girl her fortune. Little girl, you will soon be the mascot of the New York Rangers.

LADY WITH BREASTS: Oh god here's Bob Heman published in BLUE SUEDE SHOES. Far out.

BLACK OVAL: Ovals don't kiss you know. Don't kiss each other. You can kiss me if you're not an oval. Movies never kiss you though. I've always liked being an oval, but I still can't resist movies. What if the movie kissed me?

LADY IN THE CLOCK: If they can take it for 10 minutes, then we can play it for 15. That's our policy. Always leave them wanting less.

BLACK OVAL: This is one of those great movies where absolutely nothing happens.

LADY WITH BREASTS: Red butterfly. Red butterfly what? Red butterfly, red butterfly, red butterfly. I wish real being green new liquid now. I wish. I wish. Butterfly alights on grass, switch on the fan.

LADY IN THE CLOCK: Why don't you write a poem about your breasts while they're still presentable?

WIZARD: Little girl, you will grow up to be Tina. In your old age you may found a religion.

LADY WITH BREASTS: Here come our owners, everybody!

Scene 2

MAN: The pictures are all crooked. Look. They're all disheveled-looking. Am I imagining things?

WOMAN: My half-nude portrait looks positively interrupted.

MAN: Let's straighten all the pictures and take a different drug. And go to bed.

WOMAN: You do that. I just got a couple of lines for a poem . . . I think.
 My breasts something
 One is a red butterfly
 The other the property of Tu Fu . . .
No I mean
 My breasts conceal a black oval. And actually
 One is a wizard, the other a
 Little girl named Tina. Actually . . .

MAN: That's interesting. You've never written a poem about your breasts before.

WOMAN: Maybe it's really going to be a poem about a black oval. I'm not quite clear. I think I won't write this one yet.

MAN: Let's go to bed. The lady clock is stopped. But my watch says it's 4 AM.

Scene 3

BLACK OVAL: I need some more popcorn. I'm going to stay up and watch them sleep all night.

LADY IN THE CLOCK: My face is happy numbers . . . It glows.

LADY WITH BREASTS: You're just a nude without a face. Your face is a clock! My face thinks for her while she sleeps, it'll think for her when she's old, when she's dead. I was painted that way that's all. Her breasts will always be presentable.

LADY IN THE CLOCK: Artisty sentimentality, dear.

LADY WITH BREASTS: We'll see.

WIZARD: Yes, little girl, but first, you'll feel like a beautiful shoe, a monarch butterfly, a Greek orator addressing an empty couch. You'll join the circus and stuff. You'll make mistakes, you'll try to clean the kitchen with Vichy water and tampax instead of a sponge and ammonia. You'll get the hang of being a person, I'll help you out I invented you! Now start to remember . . . remember the balcony, the corridor, the front of the hotel, the purple night, the coffee shop near . . . remember what it felt like to be very, very old . . . remember claustrophobia and heat and fireworks . . . remember . . . remember what it's like to be that sleeping woman. And now Presto! you've forgotten nearly everything.

BLACK OVAL: This good time go smooth in its rounding.
 This good time go smooth in its rounding.

BLACK OVAL AS WOMAN: . . . at school was always. Pressed the button, started revolving. With a melody so your brain can torment you. The same street the sky with whoever was there. I loved that hard-to-figure-out glass. Terribly Sonny terrible. That ought to do it for me one way or the other. No there's more. Ever walk through rooms? Centrally beautiful; was opening; I slide over projectors. Kiss the first fraction of each note. How can I kiss the rest? There was something juncture. Just take the whole next note. With a whole kiss.

BLACK OVAL: What a great movie kiss! What a great night!

WIZARD: Want to play cards, Lady in the Clock?

LADY WITH BREASTS: She doesn't have time to.

LADY IN THE CLOCK: Aren't we bitchy now!

BLACK OVAL: What a kiss! What a great kiss!

READING EVELYN WAUGH

Last stage of sunset over a plain flat expanse. Most of the sky is still twilit blue; there's one star; the lower sky is still rosy.

Blue Sky: Marine Rose is rapidly failing in health.

Rosy Sky: I am getting a suit of blues to wear of an evening.

A woman enters: She's in her mid-thirties. She's carrying a rather large book.

Woman: I don't care what everyone says. I can tell by this book of letters that Evelyn Waugh was a very nice man.

As the last of the rosy sky fades a bench materializes. The woman sits down on it.

Woman: "Poor Sexy had a terrible day." You said it. I wish I hadn't finished this book this afternoon. What can I do now? I want a new thing to happen, some mysterious unheard-of thing that I've also always liked. Oh I don't known what to do, so much that I just feel sleepy.

She places the book at one end of the bench & lies down on her side using the book for a pillow. Falls asleep. The sky darkens still more & other stars appear. A woman who looks like the sleeping woman enters.

Woman II: What to do in this dream.

She takes off her blouse. Stands still a moment, shrugs & says:

I'm already bored with this dream.

She exits, blouse trailing in hand. She enters again, still half-nude but with her hair done slightly different, say pulled back & up with combs with pink rhinestones:

She's called me back. Well then I need a chair.

Pulls chair out of darkness & sits down:

What does she want?

A non-descript man enters.

Man: Could I interest you in mountain-climbing?

Woman II: (*a little stiltedly*) Yes, I've always loved to climb mountains.

Man: I know of a tour of Japan which includes extensive climbing of the Japanese mountains. If we impersonate a married couple we can sign up for the tour.

Woman II: But we're strictly illegal.

Man: Yes, we are.

A Japanese man enters carrying a clipboard.

Man: It's the tour guide.

Woman II: (*Still seated, but now sounding mildly interested*)
Excuse me. We would like very much to sign up for your tour of Japan & its mountains.

Japanese Man: You must be married, of course. You will share the same room & even the same bed.

Woman & Man look at each other with shy light-filled smiles. They whisper to each other while the Japanese tour guide writes on his clipboard.

Woman II: I can trust you can't I?

Man: Of course. We're not interested in sex, we're only interested in climbing mountains.

Women, Man, & Japanese tour guide exit, the Japanese man walking faster, in front & carrying his clipboard, the man & woman together, not touching, but stealing meaningful glances at each other. The woman on the bench, still sleeping, is prettily spotlit as the curtain falls.

73

HISTORY OF PENNSYLVANIA

The setting is Dreamtime. Very misty swamps plus sleeping nighttime cities, plus sense of dumps car pieces burntdown buildings, & plus sense of house of endlessly rooms that are full of people. Continuous murmur. Above which, voices chat in the mist, visible people talk too.

VOICE: In Virginia, from whence he knew I came

VOICE: He told him that the Russia

BLONDE MAN: It never occurred to me no one had been listening to me for about 2½ months.

BRUNETTE MAN: That's the story of your life.

BLONDE MAN: There's a lament for a girl too. After the first great crisis of my life, Nope, before I saw it coming. There's a lament for a girl around line ten there.

BRUNETTE MAN: This poem needs some pandas in it.

BLONDE MAN: Pandas?

BRUNETTE MAN: Or you could tell what the hell happened. Say, when the summer ended you broke my heart but not my real heart.

BLONDE MAN: I'm in love with the place-names of battles.

BRUNETTE MAN: Let's exit. I have to read Edgar some more.

VOICE: The back cover that has all the apples

VOICE: They sit around in their tee-shirts & look bad

WOMAN: And then I said to him, "He says that even more than LSD you hate sutras." Who were those two men? And then he, whoever he was, said, Don't you want one of these penis-shrinking codeines? I said, No my penis is already small enough. I hate catching a cold before I wash my hair. One of these days I'm gonna not be a jerk but I don't know when. I'm calming down I'm asleep. Frosted amethyst.

VOICE: She's so dumb she's asleep.

VOICE: I'm a hundred years old & I never did that for hundreds of years.

WOMAN: Every man got dreaming. Sometimes he might be fish, or kangaroo, or emu man. That way he can't kill his own dreaming. Lilly corms, snails, & wild honey. In the bush we are closest to things we know. I'm by way of fraught madder. Sometimes she might be shell or frosted amethyst woman.

VOICE: I dreamed I had a new alien girlfriend. She was just like you but she was from another planet where they thought money was worthless.

WOMAN: I know, I know. We have seventeen cents when I wake up.

VOICE: But then you get a personality & you're STILL pissed off because that's still not it, I mean you.

WOMAN: I know, I know.

VOICE: This book is about imitating being alive a citizen & a poet in order to be that. Hand me another *Noche Buena*.

WOMAN: Here.

VOICE: Thanks.

WOMAN: Save the label for me.

VOICE: You crazy?

WOMAN: I know, I know.

BRUNETTE MAN: Alice? Alice? I thought I recognized you before.

WOMAN: Oh Hi.

BRUNETTE MAN: I am Alice Man.

WOMAN: You mean you still love me?

BRUNETTE MAN: Sure. Johnson was always helping poor people. Just like me. Seventeen cents. Then I said to him, "Say: You were concerned with my feelings but I was concerned with my odor."

WOMAN: Ha ha ha.

BRUNETTE MAN: Hand me some of that raw red ochre there & the juice of a

chewed orchid. Hand me that there bark. I'm going to make a painting.

VOICE: Human beings read the *Times*.

WOMAN: I feel a lot better.

VOICE: Dying for sugar & doing prostrations. He hid the cigarette in the flowerpot.

BRUNETTE MAN: This painting is of my water hole. That's a town in Pennsylvania off over there. When you turn this painting upsidedown & shake it, petals & snow fall on you. See?

WOMAN: Oh it's beautiful. They feel nice.

BRUNETTE MAN: I see Megan coming towards us. Don't I? Friendly lamppost.

WOMAN: Let's go say hello.

VOICE: "Ah Bath" in script

VOICE: Alive alive oh

VOICE: And do some other horrifying thing

VOICE: Visit the libraries of Oxford.

WALTZING MATILDA

for Jennifer Dunbar

12/2/80

I am an exhausted not-that-chrysanthemum Oh brother
Nothing's funny nothing's pretty, all the jokes
& gems collided at Gut Corner & then they did that
you know rolled over & over down the hill to the bottom of
 the tin-can gulley
And then there's me you know I that am like a stomach sick of.
I miss Barbara Nichols & the death of Apollinaire.
And can't live up to the presence of a flower or of
Anything else. Her dress. it was stunning. Very
Low-cut around the tits & black velvet she was
The cut flower for sure. He said her tongue felt like
A live animal. A lot of up to her panties & then I
Put that magazine down & take your temperature. 101.
Get under the covers honey. Okay? 'kay.
Real-life juxtapositions are the most tasteless. 'Cuz
Pretty soon I'm gonna take your temperature again & then
Back at the text she was naked. She was naked & in her hair,
Positioned enticingly on the table amongst his pile of
Law reports. I'm sick of this, this dum-dum logistics of it
all. Mom I don't think I'll throw up a, if I make a
peanut-butter-&-jelly sandwich I won't throw it up
this time. I guess it's really raining. Didn't you
Hear the thunder before? it was thunder in the kitchen.
How do you free? Why didn't they have a democracy
On Prospero's island? Something smells funny it may be
My socks or a fragrant flower. It's my socks they smell like
A rained-on tree that smells like feet. I don't re-
member what it's like to be a tree, but there's some
 people seem to.
She was naked but she got up off of the law reports
she said she was absolutely ripped on an old-fashioned
hallucinogen, she said all that paper recalled to her
her tree self but that was either after or before her feat of
radiant concentration which changed all the law-report words
to their tree-language equivalents so when he looked at the pages

77

he saw in brownish yellowish reddish green such verses as

 Bark must not
 do potato, tomato.

 A leaf is local
 only while falling.

 "What? like a gavotte?"
 the common evergreen rustle:
 hours & regulations & so on . . .

But what about my throbbing member? he said & began to
chase her round the table & when he almost caught her by the
 before he even
felt it her pubic hair was become soft moss on bark. Mom
 why don't
people read in the dark? They can't see the words in the
dark. I can. Please go to sleep now. Please, honey.

Next day sunlight smashing into the pine boughs & orange peels. December sun blinding white cup of water germ. Temp. 103 degrees. Face of white mum also turned intelligently towards TV. Somebody's dog & some elves are in prison. Continues. This kind pine has clusters of needles at end of smaller branches of branch, like glossy little whisky brooms. Sun moves, I'm not so dazzled now. "He was one of those guys not Little John---the pie or something"---"The friar?" "Yeah. I saw that with Elinor with Bloody Pie or something"---"Captain Blood?" "Yeah."---"The Greeks' greatest heroes & stuff. Like that. I liked the whole thing. Somebody like Jason came by, & he knew his trick---the thin guy kicked you over the cliff when you washed his feet---& I think the thin guy got kicked over." "Ow, ow. Ow, ow." "Why was Edmund saying Ow?" " 'Cuz he was copying the thing of what Tom said." "How'd he lose his momma?" "His momma went out & Tom stole the egg." The sun moves too fast, I'm cold, there's my panties on the floor as usual, as usual my most colorless pair, "Ma, hand me my water." "Here." I'm not coming through. And I know it's right next to me. If I say I'm two pine boughs that's cheap, that's cheap continuity, "With a guy named Hans & that lady's being attacked by a dimetradon, & he throws a hook in the dimetradon's throat. And Alex gets thrown into a tree." "And he gets naked." "Oooh he's smelling garbage." The green needles now have a grey gloss to them, their shadows streak the white of the cup, the orange peels will never be rearranged, I'm not quite losing it, I wonder who this is all for, I picture a shadow sort of courteous man bending over my shoulder & saying quietly, "Don't forget the seed & that it was really a tangelo, not an orange, would you like me to rub your neck a little? You're guilty as hell but you're only a thin wafer of light my dear I know that's not or is scientifically correct note your cloud sample skeleton and all that remains, the bright smile, the sample babble, a marble bubble. It's getting sombre in here it's time to cook supper, goodbye my dear, (I cook too, I'm making eggs orientale in G minor with real midnight truffles & chicken soup.)" His wing. One wing. "You kids want jello & chicken noodle soup again tonight?" "Yeah, I'll have some." "Hope I can eat it & not have to throw up."

12/4

I remember so much that I generally don't ever
want to talk about it But first will you answer if I
ask, I said something like, he was as good as the
best, And she looked at me between loyalty & me
All right you dumb broad ex cathedra infallible bull-
shit in ex domine & the rest of it forget it, 100 degrees and
Yes she admitted, he's a real one, he's a great as I'm glaring at you
& this jackass was already falling on the floor talking about
parataxis & parthenogenesis, he lost his hardon for the
scene &
 be generous. It's all
yours. We're still all sick but there's his shut-eyed
theory of the great crocodile of the or whenever in
this too cold life fork it over anyway it's all fun
& tired & sad, how to live, read the mail, & that
that looks like it's got things called leaves but didn't
ever say so itself, I'll see you then oh my, til Sun
boy oh boy, Alice hey can I have one of copies?
Sure I gave to life all that I had it's cold like
'cuz even if you look you just miss it, that makes
me think I did something of our own before the next
fucker whirlwind & meanwhile if your name is
Nell & you sign the note Nellie the world
is improved a whole lot at least mine is
& put stamps on with masks on them from Tlingit & Bella Bella

Did I give him enough aspirins? 101 degrees.
Well night the last hmmm He started the boiler-making at 5:30
I'd like to take this opportunity to say
I drank too much but couldn't vomit at 3 AM when
he flung handfuls of white crosses at us & so I
woke high as a kite at dawn & everything was as
fuzzy-looking as usual for a myopic person in bed but
behind my eyelids it was something else the
clearest-cut of mind-boggling fleeting pictures
½ spring ½ shrimp salad sandwich ½ terror excursion
so I went back to sleep & got up today
& I still lived in the same house etc. what an
amazing fucking life you see I recently had this
dream that these various Chinas were on the march & in
the great primeval World War after I got tortured by
the bad Chinese when they tied me up in sort of fine

barbed wire well after that & when the vast good
Chinese horde had won & I'd found that my torture was a
dream you see it was also still my information
so I still had to tell it to Arab Chinese leader lady in black
& when I told it indignant & righteous & this is the point
of my speech now, when I told it to her righteous I felt I
was being more righteous than it had hurt really
though I felt I was telling in tone & way appropriate to
human being, so, so, I mean how much does
it hurt, it hurts, but it hurts me sorts itself out from
so much that you must be & then you have to learn
to be indignant or you won't ever tell her about it
the world has sorted itself out in the oddest way
You see? The lady was kind & offered food
to be eaten with the hands in a
room like a cave all torchlit full of musicians
dancers & populace all brown all of them all over

Dec. 5, 1980

Dear Adviser,

This is my problem I think. My husband is mad at me & the heat's off it's about twenty-five degrees outside. I plugged in the space heater & blew a fuse but I fixed that I'm so handy. I am having troubles with my writing because the words aren't jostling each other glitteringly in a certain way & they all have referents I think if that is a trouble. Now when my husband left the husband I mean house this morning shouting at me due to provocation on my part via tone of voice & inability to say the right nouns that would wake him up so he would fulfill a professional engagement involving a friend of ours, this gets tricky here, when he left shouting at me he shouted words to the effect that he was beginning to realize he should start batting me on the head more often when he felt like it that was all there was to it. Adviser I am of many minds to bat on about this. I feel like getting a provocative tone of voice again or being very grave & saying he's gone too far in speaking of batting me on the head or forgetting about it simply & lazily but should I let talk of batting me on the head simply pass by is it wise to forget it but it is certainly the easiest thing to do & it is so cold. Meanwhile I would like to point out that my husband has never batted me on the head or come remotely close to doing so & I would like to point out that his sentence to me, "I should start batting you on the head more often . . ." seemed to imply that he had. Do you suppose my husband woke up thinking he & I were two other people I mean not ourselves but say Reginald & Felicia or any two other names, or do you suppose he was momentarily gaga as I believe they say in England and imagined he had once or twice batted me on the head? Or do you suppose by "more often" he meant that after ten years it was probably about time he started, I am disturbed about all this you see because my husband, you see it's all about usage of words & to say what you intend to & he has always in the past been excessively careful with words, we both read $L=A=N=G=U=A=G=E$ magazine. Do you think he has another wife or woman somewhere in the city that he bats on the head or do you think he has one of those peculiar "lexias" one reads about here & there but a speaking not reading kind & would that make it a "lalia"? Or do you think he simply got mad & spewed out some words any words Dear Adviser? It's getting colder in here so I must end this letter & do something to get my circulation going as they say perhaps walk downstairs & see if Poor Old Crazy Diane as my friend Molly calls her is arranging the garbage cans neatly & in straight lines even though it's cold out. Do you think my husband wants to bat me on the head because I indulge in such frivolous pastimes as Poor-Old-Crazy-Diane-watching while he is out teaching & fulfilling professional engagements & making the money that doesn't go far? Could you answer me soon preferably before five o'clock today?

Yours,
Anonymous

P.S. Or do you think by "bat on the head" he meant something loosely metaphorical? Then again.

P.P.S. Poor Old Crazy Diane wasn't out so I came back upstairs & swept the floor & chatted with my sick son whose temperature is a little over 97 degrees now. I took my own for kicks & it was exactly the same as his---it's *cold*, man.

Dec. 7, 1980

Dear Anonymous,

Glad you met me at the old saloon
It's that your husband just was shone on by the gypsy moon
I give the same advice to everyone for everything
But it always sounds as different as, that every time you sing
A song you sing a different song because you're tone-deaf
At least I am. When the gypsy moon shines then there's this sheaf
Of people that they each become a fallen-apart sheaf, even
If it's morning, the gypsy moon can shine, even if it's heaven
In the corner of the room in your brain where you read
The book of Crystal or Murky while you walk about & lead
Your life & lead it to the bathroom & the coffee & stuff.
"He likes Jim Carroll's songs" oh that was advice for someone
 else some rough-
Spoken creature whose husband threatened her with a carrot
In an orifice or up it because she hated it while he worked at
The realization of his favorite artifice a song that would combine
The virtues of the shoe & the pillow, King Kong & the helicopter,
 the pine
& the leather orchid: a song to be called "Language on Vacation: Haiti"
Well even I your Adviser a most distracted individual see that
 obviously that's another story.
"Why didn't she give me phone numbers for all those millionaires?"
I'm distracted again, forgive me, I liked your poem "Western Wind"
 & all those airs
Of yours that others sometimes call "immense horseshit, goddammit"
(I can't even tell if I'm actually getting anything done oh shit.)
As for the gypsy moon, it has no definition or explanation
It's a useful phrase for when there's free-floating fuckup & the one
Thing was then that shouldn't have had to be---It's a concept
That saves shrink bills, makes love affairs still be affairs, you bet
Instead of just love, & promotes friendship & heals the sick
At heart & gives glory to those that ain't making it, thick
Mantles of moonbeam sunshine that people wear as they sigh
& say "Last night was my worst, I must reconcile myself, I
To being not only a half-assed minor painter but a half-assed minor
Practitioner of fellatio & a periodic psychopath or
Social seismograph like a person in the papers which
Do not a one of them believe in the phenomenon the comfort the magic
Of the gypsy moon that when it shines for you & no one knows why

84

Or why it shines also for some seemingly random others, I
When it is I, absolutely weird myself out Oh boy."
"Gypsy" because you've wandered off into the woods with the silver-
 ware or boy
Or girl baby person self of someone else or something like that;
& as for "moon" well you must know why, as for where it's at
This gypsy moon, it's up in the sky, but you only know it's yours
After you've done what you did. So if down on you & your husband
 it pours
The light that wreaks temporary change the kind that distresses
Remember it's not psychology sociology numerology history or you, it's
 the gypsy moon's shivery long dark white tresses.

Best Wishes,

Your Advisor

P.S. My own temperature is a perpetual 101 degrees.

*

Probably that's the only beauty you can have anyway. The kids got better yep. Generally you like to believe that people behave in other ways on such occasions. During the readings man it was so super. So I mean you know. I don't know where they came up with the figure. I do have it but putting it right next to my bed here. Right. That's the stuff that sticks into you. I fought for the South in that one. I'll forward a few to you you ought to enjoy them. No man he had this money thing on his mind---Jesus that's funny that's okay it was that night otherwise he'll have another one tomorrow. That was a little magic incident too. She even enjoyed puking, ha ha you guys are horrible. It was great. They went the next night too, I mean it's different here now. Past histories etc, but when you do it's you you're not *for* anything or against anything, I was really happy about it, & she told me she was really pleased, & the beam of attention from you made a world. You look & you listen. You gave an honest day's work for an honest dollar. & the other so for the sake of saying that. I had some opinions too given I was in X situation also I did know you wouldn't be in a snowbank dead. Man we'll do this again & we'll do it somewhere else again too. This was one of them I thought. You showed up at the right place instead before everybody else. Because I asked you. Right. Holy Shit. Right. What's happening Baby? Were you sober by then? Thank god for that, if you've got some piece of identification that shows you're something. And the times the cops handcuffed you & threw you in the car. All you did was take a turn too wide or too narrow. And hit a tree & fucked up your life for nine years. Hey wait a minute I presume you might find twenty-five dollars, oh great. No it's not no it's great, I read a little piece it said this guy should be hung. Yeah well that was part 2 you know in New Hampshire snowed-in anything. And after that you were a little hard to find. Who's being asked, who's giving, who's not? I'm just doing the calling & asking. But the personal voice thing is better but I'll talk to you soon I gotta fall apart you know. See you.

12/9

All I can say it's too pretty damned
bad. Bless Ringo's heart he just got
on an airplane & came there.
Gee whiz it's all fucking heart-
breaking,
 What did Judy say?
She said, Shit.
 It's grey what
can you say? Everyone in New
York's staring at the newstands
thinking what you were think-
ing & thinking that every
person on the street's thinking
the same thing,
 They're very good
at choosing who to shoot,
they're very good at choosing the
one whose death makes you
feel most killed---or most
culpable---
& the Mayor & the President-Elect
have to make idiot speeches about
gun legislation---because a reporter
asks them---either for or against,
& state their "position," when what
they both want to say is If I
had a gun in my hand right
now I'd shoot that sonofabitch dead---

what's that noise?
 that's a kid---
it's all so commonplace, it's all so
like us
 Daddy you said he had a
good life,

 Why should a guy with
a five-year old son have to get that?
Ringo looked like my uncles at
my father's wake---& my mother
could hold herself together, but

every once in a while one of
my uncles would come out on
the porch & push his hair
back from his face---all
the men in my family do that
when they're worried or hurting---

That guy was in our life.

*

It can be later the same evening not the way I had it to begin with. One of them was & to no purpose. I can't I can't lose it quite simply, this minute this quite simply this, even though I can't quite I almost finished this quite cheap way of getting it which is answering some other person's that or philosophy. And then pay some more, let's go find him in Maggie's whorehouse & take the bottle away. Your play, quite simply your Fate says, I don't know what that means. The handout child long ago Beauty's Other, I don't know what that means. Fuck 'em. Look just give me about five thousand. Then we guarantee the beauty be taken care of, I just realized I don't know any rich people. Man just give me the fuckin' rent money, it's for someone more beautiful than me, the other me, the need glee depressions feeling, the beautiful homosexual I used to be. It's much too late for me to be up worrying about this, children get up soon, my panties all unwashed, I something something my tits & said no green-grey clarity all day dammit poseless in a turquoise nightgown inside from a silky rain. There's no one more beautiful than me though, no. Jesus this poor girl, she really fucked old Shep, she got the inner ear scene for which there is no cure & I don't know whether to give her a B or a C. Fuck her inner ear. I give her C.

Dec. 11, 1980

Dear Adviser,

I'd like to ask you about yesterday
where should I start? I had a blister
in my eye, that's what it looked like & my
husband got a check in the mail so it
occurred to me, after three days of staring
at this blister, that I could actually
consult an eye doctor, my eye doctor.
The nurse said come at four but I went early
spent 20 minutes in Bloomingdale's
staring at Chinoiserie & jewelry
people were complaining about how long
it took to get waited on, a man said
"I want to buy a single gold bracelet."
I coveted some amethysts & left.
The doctor said I had a virus in
my old eye-operation place & shouldn't
wear my left contact lense for about a week.
So Dear Adviser I'm now lopsided.
Meanwhile my husband & I went to Hoboken
last night where he read his poems in a
restaurant place & I got drunk on wine
& Peggy's damnable bottle (Peggy's
my friend). We came home whence I took up
residence on the bathroom floor
I sat & laid there & groped for the toilet
tried unsuccessfully to vomit
I was very sarcastic to my husband
"Can I help you?" he said "Oh *sure*" I said
"Wouldn't you like to come to bed now?" "Oh
sure," I said, "just like *you* did the other
morning." He said I said that enigmatic
sentence, he said I said sarcastic things
to Steve, our babysitter, about Steve's
ex-wives. He said I said I'd written a
voodoo poem, set in New Orleans or
somewhere, for which I'd surely be
assassinated just like John Lennon.
Now, Dear Adviser, things get tricky---he was
having fantasias & nods, due to fatigue & drugs,
when he told me about how I'd acted last night,

early this morning. I am *not* working
on a voodoo poem, set in New Orleans,
though who knows what I said? and he retold
the evening from Dreamland, & room upon room
of other worlds of things that hadn't exactly
happened---these rooms we did walk through Dear Adviser---
as he told of the three famous poets we
met on the streetcorner, & Rosella in the hotel
this Rosella said something & there was a
car ride to another city & every five
minutes he'd say---Peggy having shown us
her first two real poems---"& Peggy's two poems were
pretty damned good!" Well they were & I re-
member that, & whenever for five
minutes we were vaguely somewhere we weren't
or hadn't been he'd suddenly say "Peggy's two
poems were pretty damned good!"
About 9:15 this morning he e-
merged from that state of consciousness & said
that when you were in that state you noticed
that people hated you for it & that
you noticed that people's everyday con-
sciousness was characterized by how they
felt so righteous. Then he slept for two more hours
then went to work. I have felt hungover
& chagrined all day. Dear Adviser I'm
not sure what my question is except
I don't mind my having flailed around on
the bathroom floor, & having been mean &
sarcastic, & having accidentally
broken the alarm clock face's glass cover,
which Steve had to sweep up, & never
being able to vomit, & my dream
of Steve feeling me up briefly under
my gown & saying "I just like to keep
sure my friends are all right," after which we
each ordered a meal in the cafeteria,
I don't mind my husband's amiable cosmic rambles,
I don't even mind my hangover, but
I truly hate the thought I might have said
that stuff about a voodoo poem & how I'd
be assassinated & all. My question
is, Dear Adviser, fourfold: 1) do you
think I said it? 2) do you think
there's something odd about my priorities

& values? 3) do you think I'd have had
more fun if I'd been fucked up like my
husband was not like I was or do you
see little difference between us?
4) why do you think I mind I might have said it?

Yours,
Anonymous

P.S. Later. We made love a little while ago & my husband said it was better than
both Picasso *and* Judy Garland. But I guess that's just bragging not relevant.

Dec. 12, 1980

Dear Anonymous,

To answer your questions in order. 1) Did you say it? Of course you said it, you either said it outright or said it in his imagination, but either way you were saying it. Do you think you own yourself? Ha. Ha. Which isn't to say you aren't free, but you never know where on earth or in heaven you're going to be being free. 2) Your priorities & values, something odd about. Actually I rather like them. Saracasm & meanness & inability to vomit etc., they just occur, & the husband or the babysitter they can then go fuck a duck if they're perturbed. What's odd about your priorities & values is that you don't see that about voodoo in New Orleans, assassination, etc.--- saying that just occurs too. What you seem to hate is whatever you don't remember. Oh let go let go, dear Anonymous! Just imagine what you're doing & saying in *my* amiable cosmic rambles right now! You just told a drunk panhandler on 3rd St. you had the best breasts in the neighborhood & so didn't & wouldn't ever owe talentless him a penny; you just told one of your sons that you loved him so much that you were lost forever, lost forever, you repeated the phrase trying to find it out; you just told your husband that you were writing a voodoo poem set in New Orleans or somewhere, but you said that with the rain you occupied a white scared sidewalk there. 3) I see little difference between you & your husband---you're both big and awkward sentimental truthtelling fuckups though you each have a different cover story. Do not envy your husband the cosmos because you put in some time on the bathroom floor; the positions may interchange next time. 4) Why do you mind so much? Because you had to mind about something because you're alive & a string of words was the easiest thing to mind about, it was just an object. So what if you're obsessive? So what? The wind is beating at the windows & it's cold & trying to tell the truth is boring when there are only two possible truths to tell: A) that your life is subject to the manipulations of the rich & powerful & acquisitive & the interferences of the mannersless & suspicious & judgmental & desperate; B) that you are this minute catching yourself at aging, loving, baby-sitting, being vain, washing the dishes, being complex, etc. Now I suppose you're asking why B) is boring. It isn't except when you can't tell it because there is too much of A) going on in your life. So buy yourself a Fischer-Price Activity Center, some glue & scissors etc. & get on with it all.

Sincerely,

Your Adviser

P.S. My wife says "better than Beethoven & Patti Smith in their garterbelts."

12/20

Here's another scenario: He says
What we don't need in America is peace & harmony
What we need is strife & revolution
But what he doesn't realize is you need whatever peace &
Harmony you can get because most of your life *is*
Strife & revolution. What if he did distort the facts a
Little he didn't distort them too much but he had a
90 thousand dollar house & that ended it with us
Right there. But *him*, when he's confused
He says I'm confused & asks the advice of
A penniless bum poet, a poet whose poems he doesn't
Really like, & whatever boy he's sleeping with. That's
Sense. Well we can settle down for at least a half hour now.
Are you in a position to sell ten? Go call Johnny.
I like society again, I think it's like in Charles Dickens
I'd been thinking too long it was like a Christopher
Isherwood book. Now I know I don't have to save
The queers from the rich people just myself from the rich
 people. Poetry
Is totally bad for the brain. When I talk that way I can't
Stand myself. I have hysteria. What the hell's gonna
Happen tomorrow or any other day? I'm afraid I
Just blew my chances at the Nobel Prize. I won one
Of the prizes *I* give out. Do you think he
Still has fun? He has fun going for walks, say
On the way to the Ear Inn. He sees a girl's dress
Fall off her & a dog run away with it in his mouth. You know
The kind of thing he sees, then he has fun.
 What
Did you say?
 I think most
Electrical appliances can be repaired via nipple.
Christmas tinsel & same old angel. You can't
Do yourself right by yourself. No white
Shall ever see the tears of a Menominee. It was a full
Moon at 5 PM & pendant in the sky which wasn't
Dark over the park, the same park where in
My dream of this morning the Martians landed.
A silver cylindrical aircraft that I knew was the
Martians because it could lower & raise itself
Absolutely vertically, so I ran into Marion who was rushing
Along looking happy Wait I said there's the Martians

& I ran over by the bandshell & grabbed the kids
But then the spaceship really landed the Martians
Landed. Then I woke up. It was a good dream
Because it was the next day. The Martians had landed. I
Got up & ate a bialy & made myself a little pot of coffee.

12/21

So what if I'm no longer Valentine Venus? I want to address you somewhere beyond whether or not you "buy it" or not, I want to decline the magicianship in order for you to be present, right here. The door opens the cat leaps to the floor, "Aaah, what happened? I just thought of something funny but it can't be it must be a coincidence, forget it. That guy doesn't understand that the world is all hooked together like whole series of clocks, he just ain't serious enough & that's what Kathy had against him too." If I had to choose between being reflective or showing you my garterbelt I'd rather show you my garterbelt if I had one. We can do anything we want we can fly just by flapping our arms, Oh Dear, I want to address you without saying pompous things about garterbelts. So did you go to the bookstore? No it was closed. Hell, he seems to have very little beyond ambition & that's not enough. My god, me I just heard the word spatula & went waltzing Matilda. But everything's such chaos, she's trying to make our life more difficult. But it's still terrific of her to think of it. Matilda of the steamed clams, the stew, & her hali*but* with the *butt*er sauce, my darling who finally taught me you can't try to change without try & change world or rather be in it differently not in oneself differently so much well I'm too old to be publishing such kindergarten revelations but this one requires that and that I'm sorry your Matilda tape's broken & this song won't exactly replace that song but won't you go a-waltzing Matilda with me if I at least show you my garterbelt, Which one? That one, that's the one that's the manic Christmas lights flashing on & off. If we don't have to wait till after the showdown at the bank or what, you know where I meet with the priests of Mars, and how can I ever clean this up? Or should I mess & blur beyond all recognition until I become a magnificent suffix or something, Well then I made a Christmas Tree & sat down, no one's gonna believe my story except you & him it's just gonna be "my version" & for two months I'm gonna be the one who went on too long as if everyone already knew the limits of everything unmade & undone yet as if love & homage & process & time were doled out like short strings of spaghetti or doses of medicine to get you through having to take & be on the medicine, but I was laughing & the hillside was streaming with light & then the storm translated my mood into its own work & the oaks were palpitating with vitality & no one could seek repose at the expense of my heart because it's their heart their spirit their character, Matilda, whether they ever know it or not.

January 3, 1981

SONG

The beautiful dragonfly is dead
They carry it from the water to the sand
"I think we have to bury him"
They cover him with a small mound of sand
They play some more, when
It's time to go they
Unbury Dragonfly and look at him again
He's beautiful. This blue. Here.
He looks like a dragon and a fly.

AN INTERVIEW WITH GEORGE SCHNEEMAN

A: The first thing I have written down here is, Do you ever think anymore about why you paint figures?

G: As opposed to painting what else?

A: Still lives, landscapes, abstracts . . . what do you like about people? Does it solve a problem for you, automatically?

G: No, no. It creates more problems than painting still lives. Right? If you're going to paint something figurative . . . the figure creates more problems. I can't paint still lives, I'm not interested in them.

A: Do you think it has to do with the fact that people are people? Or just because of the shapes they assume when they sit down? Or a mixture of both?

G: It doesn't have to do with people, it has to do with you are a people.

A: Yeah!

G: Everybody relates to looking at a painting of a person. You paint them because they present more problems.

A: You still haven't said what the problems are though.

G: When I lived in the country I painted landscapes.

A: You were there. And then when you came here you started painting people.

G: A simple choice.

A: But, you could look out the window and paint buildings the way a lot of people here do. Or you could paint streetscapes.

G: Looking out the window.

A: Right. So it's easier to have one-on-one contact with a person in the city than it is with a building or a street.

G: Yeah.

A: You can confront it more directly?

G: I would like to paint buildings.

A: You would? Why don't you?

G: I haven't gotten around to it actually.

A: But you think about it sometimes.

G: Because I like architecture. I don't have to paint buildings. It's too frontal I suppose. I mean I would like to put them in paintings, and in fact I have, a few of those paintings.

A: Yeah. And you can paint the sky over the buildings too. It would probably hurt your neck.

G: (Laughs)

A: Do you remember what it felt like when you started painting figures and what about it made you feel like continuing painting figures? Do you remember how it felt?

G: The very first paintings I did were of figures anyhow.

A: The very first one, the time you painted Katie with the ultramarine blue face.

G: Yeah when I was young I painted figures. I liked to paint figures.

A: That's what they teach you to do in art school.

G: I didn't go to art school.

A: You took painting classes didn't you?

G: (Laughing) No.

A: You just started painting?

G: (Laughing) Yes.

A: How did you know to put an ultramarine blue face on Katie?

G: I didn't.

A: You mean you just did it? I don't believe that.

G: Well I ran out of colors.

A: That's what they all say.

G: No that particular painting . . . you haven't seen that particular painting . . .

A: No.

G: That particular painting I painted something red, something yellow, something green . . .

A: You mean you needed another primary color?

G: There wasn't any color to put in the middle of the other colors except blue. But I don't think that's very germane.

A: What about in Italy when you started painting Katie, do you remember anything about that?

G: When I first started painting in Italy I wanted to paint landscapes. It isn't that I started painting figures. The fact is I stopped painting figures when I was there, and painted landscapes for a certain period of time.

A: Because you were . . .

G: Because I wanted to paint landscapes.

A: Because that's where you were.

G: No, because I like landscape. I love the landscape, and I really wanted to paint the landscape that I liked.

A: What'd you like about it?

G: It was beautiful! It's a beautiful landscape.

A: You mean that particular landscape.

G: Yeah. And in fact when we lived in Italy I went and looked specifically for a landscape I wanted to paint.

A: That was how you chose to move?

G: Absolutely.

A: You moved to Siena because it was yellow and hilly and had olive trees sticking up?

G: Right.

A: Well what did you like about yellow and hilly and olive trees?

G: That's a stupid question.

A: It's not a stupid question. I mean it might be unanswerable, but it's not stupid.

G: Well I wanted to paint a landscape, so I chose a landscape I wanted to paint, that's all. I mean there's no answer to that question. In any case, I specifically went on a trip to look specifically at places where I wanted to go and live, so I could paint in that place.

A: What other places did you look at?

G: Well, in an area of about a hundred miles in all directions . . . around . . . between Florence, Pistoia, and down as far as Perugia.

A: What had you been painting before then?

G: Figures.

A: Figures! Then you decided you wanted to paint landscapes and find a landscape to paint.

G: I was painting in Verona, painting figures.

A: And why wasn't it working out?

G: It worked out fine. I mean I painted a lot. I wanted to paint landscapes. So in any case the question is that I wanted to paint landscapes, that's all. It isn't that I began to paint people. It's that I stopped painting landscapes because I didn't succeed very well in doing it, number one, and number two we moved to New York and it wasn't apropos of living here.

A: But you started painting the figures again before you moved.

G: Yeah. Well I mean I knew I was going to move.

A: Do you remember who your influences were then?

G: Influences in figure painting?

A: Yeah. When you were first starting. That time. When you were starting again I mean. You don't remember what painters you were thinking about?

G: No.

A: You were thinking about Cézanne though all that time, weren't you?

G: When I painted landscapes?

A: When you were painting in Italy.

G: I don't know. I wasn't thinking. I was looking at the landscape very hard. I thought I was thinking about the landscape, and what it was and what space it occupied, and how to interpret it in some ways. When I started to paint figure paintings I don't know what I was thinking about.

A: You told me you couldn't come to terms with the space in the landscape. I don't really understand what that means.

G: I didn't feel that I was very able to deal with very broad, three-dimensional spaces. Because the landscapes I was trying to paint were fairly broad landscapes, and fairly simple. But I wasn't able to deal with them, primarily I felt I hadn't dealt with the space very well. I don't know why.

A: I don't know how to talk about dealing with space well.

G: Well if you look at the Mont Saint-Victoire paintings at the Cézanne show, it's hard to see how he dealt with it very well either. I mean maybe he didn't deal with it very well. Considering all the space involved, trying to deal with a very broad space in a very small two-dimensional space. You know with having to deal with only, I don't know, very strict structure in terms of a 2-dimensional painting surface and very big things in a very small space.

A: So figures were the right size.

G: Well figures are much easier to deal with because they relate to the space of the canvas more directly, number one. Number two they're much more identifiable to people.

A: Than landscapes?

G: Sure.

A: Well the other day, yesterday, people kept coming over and we kept showing photographs of your paintings to people who hadn't seen them before, and they kept saying Matisse, Matisse, that looks like Matisse.

G: From photographs?

A: Yeah. Were you influenced by Matisse at all?

G: Photographs of what.

A: One was the painting of Mushka . . . I don't remember what the others were. I thought about it awhile and then I thought maybe you got whatever it was they were talking about from the Sienese painters, a willingness to make things be kind of very long or very loose.

G: I think either one of them is a good influence.

A: Either one is. I'm just wondering which one was.

G: I don't know.

A: You don't know at all? But you're willing to admit to both?

G: Why not?

A: Yeah.

G: I like Matisse as an influence. I also like the Sienese painters as an influence. I don't know what I looked at when I was first doing figure paintings. I think probably Matisse more than say Sienese painters.

A: Matisse more than the Sienese painters?

G: Yes.

A: Do you think you're talking loudly enough?

G: I don't know. Better check.

A: Okay George, what are your basic colors?

G: What are *my* basic colors?

A: Yeah what are the basic colors you use?

G: On the palette?

A: Yeah. No, when you're painting your pictures there are these colors that are the basic colors you use.

G: You mean palette colors?

A: They're the colors that recur in your pictures all the time. They seem to be some combination of palette colors and favorite colors. Is that true?

G: Ultramarine blue, vermillion red . . .

A: Blue, red . . .

G: Veronese green . . .

A: Yeah?

G: That's it. Blue, red, green . . .

A: White.

G: And yellow, cadmium. White. I only use five or six pigments when I paint.

A: Are those your favorite colors too? Say blue, red, and white?

G: My favorite color is blue.

A: Your favorite color *is* blue?

G: Sure.

A: Absolutely?

G: Blue and red.

A: Do you think when you paint denim it looks like denim?

G: Yeah. Do you think it does?

A: No, but when I'm looking at the picture I'm always totally convinced it's denim, because all the other textures in the painting look . . .

G: You mean because of the texture or the color?

A: Because I know it's denim and because all the other textures in the painting look convincing, but your denim always looks a little peculiar. It always looks kind of velvety. I was wondering if denim really looked like that to you.

G: I guess it does.

A: You don't even put in the seams or anything.

G: Oh yes I do.

A: You do?

G: Sure I do.

A: Where?

G: Right there. (Points to painting on the wall)

A: Is *that* a seam?

G: Sure. In fact I usually put the seams in, on the jeans.

A: You didn't do it in the one in my house. Do you have a theory of seeing that's based on the colors you use?

G: A theory of seeing based on the colors?

A: Yeah. Just a theory about what colors there are to use to make things be accurate to seeing.

G: No I don't have any theory about the colors. I like certain combinations of blues and reds, and yellows, and with some brown. That's all.

A: So it's all a matter of taste?

G: Yeah.

A: Do you prefer bleached-out colors in life as well as in your own art?

G: No.

A: It's obviously not true from the way you're dressed. The blues look pretty deep, actually, on that shirt.

G: On this shirt?

A: Yeah, on your shirt. You don't think that's a matter of preference at all?

G: No. I think that there's a prejudice towards looking at things in bright colors, because we're educated to seeing paintings in terms of bright colors. But I don't think our vision, your everyday perception of color, is in terms of basic colors at all. Vision is not aimed at color.

A: What do you think it's aimed at?

G: At things, at objects in space. When you look at anything as you look at me, you don't see any colors, you don't see bright colors.

A: Well what do you think I see?

G: You see me, you see objects, you see this piece of furniture, you see that door, and you look . . . your eyes meet objects and look around them and consider the space they occupy and the distance in relation to where you are.

A: You don't think I'm seeing blue?

G: Sure of course you see blue, but primarily you don't see colors, you just simply don't look at colored surfaces when you see things in space. You just *don't*. I don't believe you do. At least I don't. I don't think most people consider the things that they see as a pictoral surface. They don't look at them as being things strung out, on a canvas, that are relayed in colors of red and green and blue and yellow. They look at objects in space, and they consider the size, weight, shape of those objects before they consider the color of them. Right?

A: I don't know. Maybe they consider some kind of emotion first, like . . .

G: Oh now you don't feel when you're looking at things, you don't consider the emotion, you look at where they are in relation to you, how far they are if you want to reach them, or what they would feel like if you touched them, or how far away they are from the other objects around them.

A: That all sounds pretty emotional actually.

106

G: Well you want to call it emotional, but my point is you don't look at things in a two-dimensional space. You look at them three-dimensionally, right?

A: You mean that's why you don't think you see colors that way?

G: The point is . . . that on one hand in looking at a painting you expect to interpret things in a two-dimensional surface of bright color, but in real life, quotation marks, you don't experience things that way. That you see things occupying space. Right? But we're educated, by looking at pictures of things, to think of them two-dimensionally and, in fact, in very bright color. They don't look that way. To me, they don't. And when you take a camera and take a series of . . . take a roll of slides and have them developed and you look at them, when you look at those things you were witnessing or whatever taking pictures, they look more intense in the slides than they did as you can remember them, because you won't remember them the way they look on slides. You'll remember them emotionally if you want, huh? but you'll remember what space they occupied, what they were doing. You don't think of their color areas. You don't look across space and think that in the rectangle of your vision the upper left-hand corner is all white or the other corner is blue or things are occupying space, these pictoral planes, two-dimensional spaces. They don't strike your vision that way, is what I'm saying.

A: Well do you think that the way you paint really corresponds in any way to the way you perceive things?

G: I think it does partly. Maybe it doesn't, but the point is if I have to answer a question as to why I should paint in such pale colors, my answer is, Why not? You don't see in colors that are any brighter than those actually. You see paintings that are in brighter colors than those, but you don't see things that are in brighter colors than those, right?

A: Well it seems to me maybe I do, but you're assuming I don't.

G: Well, I'm assuming you don't, yeah. I'm assuming that in the average light of things you're not looking at bright color areas, that you're looking at things.

A: So then what is it that you're making us aware of in your paintings in place of color?

G: I'm not trying to say that you shouldn't see color planes. I don't think that paintings have to be interpreted in two-dimensional color planes, that's all. And I think brightness of color is a relative thing. I mean when you say red, red is red. In order to experience red, you don't have to squeeze red out of a tube in order for you to understand what red is. Your experience of red can be any range of redness. In my

107

mind it's the same, whether it's a very, very light red or a very small red, it doesn't make any difference to me. I'm more or less indifferent to the intensity of colors. The relationship in a painting is important, as to how they relate to each other, and not the fact that all the colors happen to be pale so to speak or not. It doesn't make any difference to me. I mean the fact that in Fra Angelico all the reds and blues are very brilliant or bright doesn't make the paintings that much better to me. Than if they were all reduced by about 90 percent.

A: It doesn't make it more pleasurable?

G: No. Should it?

A: I don't know. I'm just asking. I think your paintings are totally pleasurable.

G: But not because they're bright.

A: No, but the color's all there anyway.

G: That's what I'm saying.

A: I mean you're dealing with color as a totally important element, you're just making them pale.

G: Well I'm not *making* them pale.

A: Yes you are. I swear to God you are.

G: I mean, they might as well be pale, is the point. And also it helps you to look at light more if you see colors in a pale way.

A: Didn't you use deeper or brighter colors before you started painting in this room in the broad daylight?

G: No.

A: You don't think your earlier paintings have brighter colors in them?

G: Earlier when?

A: Before you moved into this house.

G: No. No. It's just the opposite.

A: The ones from the other street?

A: Well then what were you getting at when you were putting the pieces of bright tissue paper on them?

G: It was a question of techniques of using paper, using paper to color areas . . .

A: Why didn't you use bleached paper?

G: That has a lot to do with getting away from painted surfaces, not wanting to paint surfaces. That's a completely different question.

A: Were you trying to break up the kind of surface you were . . .

G: No I was trying to get away from painted surfaces.

A: You were?

G: Painted areas. Yeah.

A: Because it seemed to me you were trying to . . . you were possibly breaking up the surface in those paintings, which took care of itself in the paintings you did in the mid-70's, because of the way the body came to, like, break itself up, and you didn't have to do those things anymore. Like put on tissue paper or not paint a part of the body.

G: No, here it's a question of not wanting to deal with paint because that's been done in a lot of very smart ways. One of the things I really want to do in painting is not deal with paint. You know what I mean?

A: Not exactly. Tell me about it.

G: I don't deal with brush strokes. I don't deal with paint.

A: What do you mean you don't deal with brush strokes? That was actually one of my questions, how would you describe the brushwork in your paintings?

G: It's completely awkward and ugly. And it's non-existent if it's there.

A: But that's not really true in the painting, say, that we have in our living room.

G: Well that's true. The brushwork is . . .

109

A: On the other hand I can't think of the adjectives to describe it.

G: The one thing I want, starting out, to do in some ways, is not to deal with brush stroke, not to deal with the paint on the brush, not to, you know, handle paint well. I don't handle paint well. I intentionally un-handle it. I try not to use the brush stroke in the painting.

A: Well does it freak you out when you handle it well? the way you often do?

G: Paint has been handled infinitely better. I don't handle paint well at all. I don't believe I handle it well at all, in fact I intentionally make things look a little bit bad when it's conscious, when there's obvious brush strokes on the paintings I do they look bad, in terms of technique I mean, in terms of agility as far as handling paint goes.

A: Why do you use paint at all?

G: Now I don't.

A: You love paint.

G: I like the product.

A: You don't think fresco is paint?

G: No, fresco isn't paint.

A: It doesn't have paint? that's not painting? Oh come on.

G: No, it's not paint on the brush. It's painting that you make but it's not painted on the brush. On the one hand I'm totally anti-abstract-expressionist, completely out of that. Not that I don't like that kind of painting, I love that kind of painting in a way. But painting, the whole tradition of paint-handling which begins with say Titian, something around 1500, that whole tradition of paint-handling, you know, brush-handling of oil paint is something that can't be improved on. It's all over, I mean it's been done in so many terrific ways, you know right down until DeKooning. DeKooning's a painter like Titian, you know it's these beautiful surface paintings that have to do with handling paint. Right?

A: So what are you doing with paint?

G: Un-handling it.

A: Un-handling it?

G: Yeah, taking it completely out of, off the brush and not having to do with it. But going back to the original question about using tissue paper, that was the reason. That was to be able to cover an area of color without having to paint it.

A: Ted told me I think, that you went through some period, a year or two, where you just hated to paint. You did every thing else besides paint. He told me that a long time ago. Is that why?

G: Yeah. I hate to paint in a way.

A: Is it a kind of loathing of paint because . . .

G: No, it's not a loathing of paint . . .

A: Because it's all been done before?

G: Well a lot of things have been done, and there's no reason to do them again, right? I mean I don't have to paint. I can just go look at paintings.

A: So what are you doing that hasn't been done before, then?

G: Number one, my feeling is that I'm not handling paint. I don't want to handle paint in that way.

A: But you're employing it.

G: Well I'm talking about handling paint in that sense of using the paint in such a way as to create effects with brush strokes. Right?

A: So what do you create the effects with, then?

G: With something else.

A: What?

G: Well that's the next question, but the first point you have to establish is that you don't want to do that thing. Right?

A: Because it's been done . . .

G: Well that's a good enough reason.

A: Ad nauseam or . . .

G: Well yeah. Why should you continue to do things that have been done so well. And number two, those things that you see in paintings are things that you realize that your vision of things has been influenced so much by how things have been done that you have to continue to do and see things in that particular way. Things don't have to be seen and in fact aren't seen in those ways. Our vision of things has been influenced more by our seeing pictures of them than by looking at the real things. It's the old story, right? I mean things look the way we've been shown that they look by seeing pictures of them. And when you look at paintings by Rembrandt, paintings by Rembrandt or Titian or other painters, you see paintings of things that reality doesn't look anything like that, but we've been trained or whatever to believe that things actually do look like that. But they don't. They don't look like that at all. It's fine if you think they do but . . . and put down what things have been, but you don't have to go on continuing to . . .

A: And they don't look like that sometimes?

G: Sure. They look like that sometimes. But only sometimes. Which is an argument in my favor in terms of how, why should you continue to think that everything looks like that all the time. They don't look like that. They don't.

A: Well did you endeavor to learn how to paint really well before you endeavored to un-handle paint? Did you try to learn how to handle it first?

G: Well . . .

A: You don't know? Or was it all sort of one process, you knew that while you were learning how to handle it you had to learn how to unhandle it too because you already didn't want to see things that way.

G: There must be any number of ways of making things look like what you see, you know, of representing the things that you experience. And on the one hand artistically and on the other hand technically, I mean I take that particular handle on the one hand as first of all, number one, thinking that things have to be represented in bright color areas, number two that they have to be represented with brush-stroke agility, that that has to play some part in it, or that chiaroscuro techniques also have anything to do with what you really see. I mean all those things technically have to do with how I paint things, yeah. I mean I don't want to deal with some of those techniques. I don't want to deal with the paint, I don't want to deal with the bright color areas, and I don't want to deal with chiaroscuro.

A: You think they're used up.

G: Well, maybe not. But *I* don't want to deal with those aspects of painting things and painting figures. I also don't want to deal with still life as painting objects. I don't want to deal with genre painting.

A: But you do genre painting.

G: No I don't.

A: Define genre painting.

G: Well okay. Now I can paint figures in a certain way, but I have a hard time painting figures that have identifiable style and occupy identifiable places. As a room for example with a corner that's identifiable in the terms say that a Vuillard painting is or that a Bonnard painting is, you know, France in 1890.

A: I looked up genre in the dictionary last night and it said a style of painting that has to do with depicting scenes in terms of everyday life.

G: Yeah. Right. Exactly.

A: You don't think that say your painting of Ted and Carol is a genre painting?

G: No.

A: Or your painting of Mimi playing the flute is a genre painting?

G: No. No. Because that's what got me into not painting anything around the figures. One of the things that got me into painting things with nothing around them was that I didn't want to paint contemporary furniture or clothes.

A: I just told you the definition for another word. I'm really totally out of it. It was "anecdotal" that I looked up.

G: No, a genre painting's like that.

A: Actually Ted told me that you would probably define the major genres as just something like oil, fresco . . .

G: No no no, a genre painting is what you said it was.

A: It is? I was thinking it was of the (unintelligible). But anecdotal painting . . . and you do have anecdotal paintings. Wouldn't you call some of those paintings anecdotal, or maybe all of them even? They tell this little story about a person doing something.

G: Nah, not in those terms. If you are going to paint a figure, I mean the figure has two arms and two legs, the fact that . . .

A: You don't think your figures are doing anything from everyday life?

G: Not very much, no.

A: What about Katie crocheting?

G: Yeah. Yeah. But it doesn't look like something from everyday life.

A: You mean because she's naked?

G: I don't know. For one reason, I guess.

A: Well let me see. What about Ted and Carol? You don't think they look like everyday lovers?

G: They're just two naked people. I mean they don't relate to any other objects around them.

A: Are you kidding? No, but they relate to each other, and that's all lovers have to do in a painting.

G: In other words there's no identifiable historical context---furniture, clothing, and objects around them---that make it something like a genre painting. It isn't a genre painting at all. I hate genre painting.

A: I'm not really too sure what it is. You don't like Vuillard at all?

G: No.

A: Why not?

G: Because it's genre painting.

A: Is that a real reason to not like something?

G: Almost. For me it is.

A: Do you like the paint?

G: I like his paintings actually sometimes. I don't like them as much as I might if I didn't have my little prejudice. I've seen a lot of his paintings. Some of them I like.

Most of them I don't. Bonnard paintings I can take much more readily than Vuillard paintings.

A: Bonnard paintings look like they're about to buckle. You probably like that.

G: No, to me they're prettier paintings.

A: You like them because they're pretty?

G: Yeah, and less genre.

A: Oh god, I've got to get on with these questions.

G: We'll never get there.

A: Okay, you've already answered all of those.

G: What are they?

A: Oh, uh . . . do you prefer bleached . . . I already asked that one. Do you think it's a cultural trait actually to not see much in terms of color? I asked you that last night. It just seemed to me in the light . . . in countries like Italy and Spain---I was only in Spain---that you really would see more color. That one did see it more. Or in southern California . . .

G: No . . .

A: Anyway that's probably not relevant. That's not the point.

G: No I mean my point is, my attitude is reactionary towards color and things. It's reactionary to paint things, you know, out of perversity, that people will think are weak or light or pale or bleached or whatever they want to think, I mean I do that.

A: Do you think that's reactionary?

G: Sure it is.

A: You don't really think you're just too far-out for everyone?

G: No, I mean I'm doing that because it's an attack on people's estimation of color. Simple. To say you don't have to see things the way you think you have to see them.

A: Do you love color?

G: Yeah. And my own feeling about my paintings is that I'm very, very sensitive toward relationships of color. And I think color, to me it's one of the things of prime importance in the paintings . . . is the color and the relationships of white to red to pale this or light that or washed-out the other. To me the colors are of a lot of importance.

A: Why is that red so unbleached? (points to painting on wall)

G: Well . . .

A: What were you painting? What floor is that?

G: It's a rug of some kind. Imaginary. It's imaginary.

A: You made that one actually quite deep though didn't you. It's not very bleached-out at all.

G: No, it's true.

(One or two minutes unintelligible)

A: How would you describe what you like about fresco colors?

G: Given all pale colors, it's easier to interpret them in fresco, because colors tend to be pale, that's true.

A: They tend to be pale, but they can be deeper than the way you make them.

G: Yeah, to some extent. I intend in fact to make them deeper, so to speak.

A: Is that one of the reasons why you really don't try to paint in egg tempera? Because the colors will be much deeper?

G: No, no. Egg tempera?

A: Yeah! I keep thinking you really should be doing that. You told me it was the perfect medium, totally indestructable, worked every time, the colors were wonderful, everyone should paint in egg tempera; but you couldn't because you had this egg in your hand when you tried to do it. You had to work with egg!

G: Yeah, that's true. In fact I shouldn't have said that.

A: I'm sure there're lots of things you shouldn't have said.

G: Oh with fresco I'm obsessed obviously with the white. Right?

A: Yeah . . . I was going to ask, why do you think there's so much white space in your paintings?

G: Well, number one . . . the question is first of all, in the two-dimensional picture plane, to leave things out of the corners and number two to leave out other parts, so that you don't have to organize the entire space two-dimensionally. So that when you omit things, particularly in the corners, you are . . .

A: Are you scared of corners?

G: Yeah, in a sense. It's a way of trying to break down the rectangle, because when you cover a rectangular surface you have to deal with a rectangle. In composition you have to work with a rectangle. When you don't paint the entire surface you can begin to not think about that rectangular space, you can look at the thing which is in that space. It gets away from the full surface, the rectangular surface you have to paint on, right? I think I started actually leaving things out because of that, because of not wanting to resolve the two-dimensional composition of the painting.

A: Would you like your paintings to be hung on white walls?

G: I don't care.

A: All the corners would disappear.

G: Well they disappear pretty much. You can see where the painting begins or ends, but I don't want to think about the whole surface from the point of view . . . I think it's enough to have to consider the figure that's on the surface and in that space with certain elements of it, without having to think about the whole space. And even the negative spaces become positive things, huh? To me things that are left out are sometimes just as much as if they were there, because they're not there. It's the reverse way of looking at it.

A: Well the things you leave out are always still there, that's true.

G: So it's just as easy to leave something out and just as relevant as to put it in.

A: You want them to be there then?

G: I want them to be there, yeah. I mean I always think about what those so-called empty or blank spaces might be. But apparently they don't bother me as much as

117

they bother other people. I mean they don't bother me. I don't think of them as being left out. I think of them as being there.

A: Have you read that art criticism where people talk about what kind of space a figure should be in? Whether it should be in a void, or whether it should be in paint, or whether it should be put back into its naturalistic setting?

G: I don't understand.

A: I don't either. I thought you might understand it though since you're a figure painter. I've actually read it in several articles recently about Alex Katz and DeKooning and people like that. There seems to have been this question once people started painting figures again quote unquote as to whether or not they should be integrated into just this paint, or whether they should be in some kind of void, or whether they should just be stuck in the place where they were sitting or what, and for some reason that was a question, as to where they should be. Do you understand what that means at all? It seems to me you've just put them in your house, which has a lot of white in it.

G: Yeah, but I did mean that in that respect I take away things that are around people, mostly in order for you to be able to look at the figure rather than the things around it. I mean that's what is un-genre about them, because a genre painting will attract your attention to the total, you know, atmosphere and environment of what the figure's in, just as much as the figure if not more.

A: Do you think your figures are in a sort of a void?

G: Yeah.

A: They are in a void then. That's pretty interesting.

G: They're in a certain kind of void, if you want to use the word.

A: They don't seem to be in a void though.

G: Well, I'm glad.

A: I think uh . . . actually I read this about two nights ago in Frank O'Hara criticism of Alex Katz, and I think he must have been talking about those . . . like that painting of Ada in the green or the one of her in the black jacket, she's just, you don't know where she is at all and there aren't any clues. There aren't any flowerpots or anything.

G: Right. I don't actually like that idea, about the figure being in the void. I don't think of them . . . the way I think of them is being in some . . . (laughs a little)

A: Come on tell me.

G: The figures I paint are really idealized figures, right? I mean they're totally idealized. They're not in a void, they're in some perfect world, you know, they're in some Platonic world.

A: Platonic world?

G: I'll bet you didn't know I was a Platonist, Alice.

A: I wouldn't have put it past you.

G: The figures I paint are in some Platonic world, some perfect world. For what it's worth, that's where I try to put them.

A: And that's what we like about them.

<p align="center">###</p>

A: The tape ran out and you were just saying . . .

G: (Laughs) I didn't say anything.

A: You were saying your paintings really existed in a Platonic space, this ideal space, and I said that is terrific, and you said right. And I asked you about people looking quattrocento, and you said, as much as anything else. Right?

G: Now what about quattrocento?

A: Well do you want to talk about Platonic space first?

G: Platonic *space*?

A: I don't remember what you said, you said ideal or Platonic. What word did you use?

G: I don't know. Let's see, what would it be?

A: I don't know. You want them to be floating on a cloud of Mozart or something?

G: No. I mean the figures I paint are obviously Platonic in the sense that they're idealized figures as opposed to genre painting. That's why my painting is totally anti-genre painting. Because they're not ordinary people occupying some living room do-

ing the knitting. They're idealized people doing the knitting in heaven, in some ideal place. They're not these things that you ordinarily see, it's true. The things that you think that you might see, or hope that you would see.

A: When you really like a painting then, when you think you've done a really terrific painting, is that maybe what you like about it most?

G: Yeah.

A: That you've succeeded in putting them there.

G: Yes.

A: In that space or place.

G: I think so. Yeah, it's true. I think that people actually exist in that place.

A: People do actually exist in that place?

G: Yeah. That's where they really are, I mean they're someplace else than their own, I mean they don't just occupy material things, they're in some other level of existence.

A: Who knows about it? Do they know about it?

G: Everybody knows about it.

A: Everybody knows about it.

G: Of course they do. Everybody knows about it. They have to.

A: Do you think it's your duty somehow as a painter to put them there?

G: Well I think it's a good idea to make people see that, that everything that everybody does at every minute is in some other level than what it actually is. Nobody is just doing things that they're doing.

A: Would you know you were there if you weren't painting other people being there?

G: Everybody knows that they're not where they are. That everything is not what it is. Because if everything were only what it appears to be, they would all kill each other. I mean they wouldn't be able to survive a day.

A: They do that a great deal anyway.

G: Well, because they're not able to transcend any kind of level of existence, but people can't survive existence and what it appears to be, I don't think; and survive in other levels, however higher they may be from what they actually experience in terms of sensory things or what they appear to be---it's not what they are. They aren't at all. And the more they transcend the way they appear to be the better off they are. It's totally Platonic.

A: But they only transcend it by doing their daily tasks, like crocheting, playing the flute, pouring the milk from the milk carton.

G: They don't transcend it by doing anything. They only transcend it by seeing, by looking through the levels of what things appear to be.

A: But you think people should proceed with their ordinary daily tasks.

G: (Laughs) Do they have any choice? As soon as they have a choice not to proceed they should not proceed. They don't have much choice. They proceed because you have to proceed. Most of life is the inertia of having to proceed in doing the things that you do.

A: I'm getting this incredible, this sort of sound of breathing and I can't tell if it's, I'm nervous about this machine.

G: Well stop it and play it back.

December, 1977

121

WORLD'S BLISS

The men & women sang & played
they sleep by singing, what
shall I say of the most
poignant on earth the most glamorous
loneliest sought after people
those poets wholly beautiful
desolate aureate, death is a
powerful instinctive emotion---
but who would be released from
a silver skeleton? gems
& drinking cups---This
skull is Helen---who would not
be released from the
Book of Knowledge? Why
should a maiden lie on a moor
for seven nights & a day? And
he is a maiden, he is & she
on the grass the flower the spray
where they lie eating primroses
grown crazy with sorrow & all
the beauties of old---oh each poet's a
beautiful human girl who must die.